Timing for Animation

Harold Whitaker and John Halas

Focal Press

Focal Press
An imprint of Butterworth-Heinemann
Linacre House, Jordan Hill, Oxford OX2 8DP
225 Wildwood Avenue, Woburn, MA 01801-2041
A division of Reed Educational and Professional Publishing Ltd

\mathcal{R} A member of the Reed Elsevier plc group

OXFORD AUCKLAND BOSTON
JOHANNESBURG MELBOURNE DELHI

First published 1981
Reprinted 1990, 1997, 1999

© Reed Educational and Professional Publishing Ltd 1981

British Library Cataloguing in Publication Data
Whitaker, Harold
 Timing for animation
 1. Animation (Cinematography)
 I. Title II. Halas, John
 778.5'347 TR897.5

Library of Congress Cataloguing in Publication Data
Catalogue number: 80–413303

ISBN 0 240 51310 X

Printed and bound in Great Britain

Contents

Foreword

The passage of time has fascinated artists, scientists and theologians for thousands of years. Naturally they have attributed to it different interpretations, different implications and different conclusions. Nevertheless there seems to be general agreement on one aspect of time; that we are all conditioned by it and that, whether we like it or not, there is a time space into which we inevitably have to fit.

Einstein, among other well known names in the world of science, made a special study of time in relation to his research in physics. His theory of relativity maintains that space and time are merely different aspects of the same thing. Since then other physicists have pointed out that objects can be moved backward and forward in space, but nothing can be moved back in time.

Another method of describing the concept of time is through the 'three arrows of time'. The first 'arrow' is thermodynamic and can be seen operating when sugar dissolves in hot water. Second, is the historical 'arrow', whereby a single-celled organism evolves to produce more complex and varied species. The third is the cosmological 'arrow' which is the theory that the universe is expanding from a 'big bang' in the past. This cosmic expansion cannot be reversed in time. While the principle of relationships between the 'time arrows' is still to be worked out on a scientific level, the actual application of it is constantly related to all work which utilises it, such as music and the performing arts. In the latter it is one of the most important raw materials.

In terms of animation, the idea of film time is one of the most vital concepts to understand and to use. It is an essential raw material which can be compressed or expanded and used for effects and moods in a highly creative way. It is, therefore, essential to learn and to understand how time can be applied to animation. The great advantage of animation is that the animator can creatively manipulate time since an action must be timed prior to carrying out the actual physical work on a film.

It is also essential to understand how the audience will react to the manipulation of time from their point of view. Time sense or 'a sense of timing', therefore, is just as important as colour sense and skill of drawing or craftmanship in film animation.

It has to be realised that while a performance on stage and on the screen requires a basic understanding of how timing works, this book is primarily confined to hand drawn animation which up to this point in film history still comprises 90% of all output in the animation medium.

My co-author, who has drawn the majority of illustrations in this book, is reputed to be one of the world's most skilful animators. I have had the privilege of working with him for

thirty years and during this period he became the teacher of many outstanding animation artists of today.

The book itself has been in production for five years and contains several decades of painful experience. We hope it will be of value to the new generation of artists and technicians.

John Halas
London, 1981

Introduction

In a film, ideas must come over immediately to the audience. There is no chance to turn back, as with a book, and reread a section.

General principles of timing

The 'readability' of ideas depends on two factors:

1. Good staging and layout, so that each scene and important action is presented in the clearest and most effective way.

2. Good timing, so that enough time is spent preparing the audience for something to happen, then on the action itself, and then on the reaction to the action. If too much time is spent on any one of these things, the timing will be too slow and the audience's attention will wander. If too little time is spent, the movement may be finished before the audience noticed it, and so the idea is wasted.

To judge these factors correctly depends upon an awareness of how the minds of the audience work. How quickly or how slowly do they react? How long will they take to assimilate an idea? How soon will they get bored? This requires a good knowledge of how the human mind reacts when being told a story. It is also important to remember that different audiences react in different ways. So, for instance, an educational film for children would be timed in a different way from an entertainment film for adults, which requires a much faster pace.

Animation has a very wide range of uses, from entertainment to advertising, from industry to education and from short films to features. Different types of animation require different approaches to timing.

Timing for TV series

For economic reasons, TV series are made as simply as possible from the animation point of view. This approach is generally known as limited animation. Animation is expensive, non-animation is cheaper. So to keep the films lively the plots are usually carried along by means of dialogue. It is often necessary to work with prerecorded blocks of dialogue which must remain intact. If this dialogue is well recorded for maximum dramatic effect, lengths of pauses between phrases cannot be changed (except within very narrow limits) without destroying that effect. In this case, the overall timing of long sections of the film is governed entirely by the dialogue. (There could be, however, considerable flexibility for more detailed timing within this fixed overall length.)

The director has room to manoeuvre sections. So, if the total timing for all the recorded dialogue is subtracted from the required length for the whole film, this gives the amount of time that is available without dialogue. This can then be split up in the normal way and distributed throughout the film to give the best effect.

Limited animation

With limited animation as many repeats as possible are used within the 24 frames per second. A hold is also lengthened to reduce the number of drawings. As a rule not more than 6 drawings are produced for one second of animation. Limited animation requires almost as much skill on the part of the animator as full animation, since he must create an illusion of action with the greatest sense of economy.

Full animation

Full animation implies a large number of drawings per second of action. Some action may require that every single frame of the 24 frames within the second is animated in order to achieve an illusion of fluidity on the screen. Neither time nor money is spared on animation. As a rule only. TV commercials and feature-length animated films can afford this luxury.

Animation is expensive and time-consuming. It is not economically possible to animate more than is needed and edit the scenes later, as it is in live-action films. In cartoons the director carefully pretimes every action so that the animator works within exact limits and does no more drawings than necessary.

Ideally, the director should be able to view line test loops of the film as it progresses and so have a chance to make adjustments. But often there is no time to make corrections in limited animation and the aim is to make the animation work the first time.

Timing in general

Timing in animation is an elusive subject. It only exists whilst the film is being projected, in the same way that a melody only exists when it is being played. A melody is more easily appreciated by listening to it than by trying to explain it in words. So with cartoon timing, it is difficult to avoid using a lot of words to explain what may seem fairly simple when seen on the screen.

Timing is also a dangerous factor to try to formulate— something which works in one situation or in one mood may not work at all in another situation or mood. The only real criterion for timing is: if it works effectively on the screen it is good, if it doesn't, it isn't.

So if having looked through the following pages you can see a better way to achieve an effect, then go ahead and do it!

In this book we attempt to look at the laws of movement in nature. What do movements mean? What do they express? How can these movements be simplified and exaggerated to be made 'animatable' and to express ideas, feelings and dramatic effects? The timing mainly described is that which is used in so-called 'classical' or 'full' animation. To cover all possible kinds of timing in all possible kinds of animation would be quite impossible.

Nevertheless we hope to provide a basic understanding of how timing in animation is ultimately based on timing in nature and how, from this starting point, it is possible to apply such a difficult and invisible concept to the maximum advantage in film animation.

What is good timing?

Timing is the part of animation which gives *meaning* to movement. Movement can easily be achieved by drawing the same thing in two different positions and inserting a number of other drawings between the two. The result on the screen will be movement, but it will not be animation. In nature, things do not just *move*. Newton's first law of motion stated that things do not move unless a force acts upon them. So in animation the movement itself is of secondary importance; the vital factor is how the action expresses the underlying causes of the movement. With inanimate objects these causes may be natural forces, mainly gravity. With living characters the same external forces can cause movement, plus the contractions of muscles but, more importantly, there are the underlying will, mood, instincts and so on of the character who is moving.

In order to animate a character from A to B, the forces which are operating to produce the movement must be considered. Firstly, gravity tends to pull the character down towards the ground. Secondly, his body is built and jointed in a certain way and is acted on by a certain arrangement of muscles which tend to work against gravity. Thirdly, there is the psychological reason or motivation for his action—whether he is dodging a blow, welcoming a guest or threatening someone with a revolver.

A live actor faced with these problems moves his muscles and limbs and deals with gravity automatically from habit, and so can concentrate on acting. An animator has to worry about making his flat, weightless drawings move like solid, heavy objects, as well as making them act in a convincing way. In both these aspects of animation, timing is of primary importance.

Part of the working storyboard of *The Story of the Bible* by Halas and Batchelor. At this stage the director works out the smooth visual flow of the film, the editing, camera movements and so on. All these elements combine to tell the story in an interesting way.

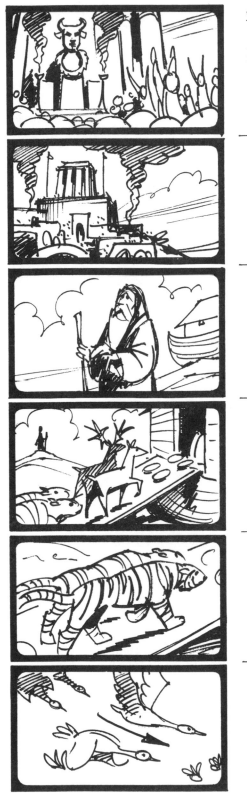

"THE FLOOD"

Fade in image of false god with people worshipping it.

Narration: "God saw how corrupt the earth had become, - "

Zoom back to long shot corrupt-looking city.

" - for all the people on earth had corrupted their ways."

Pan and track to Noah. (Ark already built in background)

"So God said to Noah - "

Mix to animals going up ramp two by two.

" - 'Bring into the ark two of all living creatures, male and female - "

Closer shot of animals going up ramp.

" - to keep them alive with you'".

Mix to birds flying in two by two.

"Two of every kind of bird - "

The storyboard

A smooth visual flow is the major objective in any film, especially if it is an animated one. Good continuity depends on co-ordinating the action of the character, choreography, scene changes and camera movement. All these different aspects cannot be considered in isolation. They must work together to put across a story point. Furthermore the right emphasis on such planning, including the behaviour of the character, must also be realised.

The storyboard should serve as a blueprint for any film project and as the first visual impression of the film. It is at this stage that the major decisions are taken as far as the film's content is concerned. It is generally accepted that no production should proceed until a satisfactory storyboard is achieved and most of the creative and technical problems which may arise during the film's production have been considered.

There is no strict rule as to how many sketches are required for a film. It depends on the type, character and content of the project. A rough guideline is approximately 100 storyboard sketches for each minute of film. If, however, a film is technically complex, the number of sketches could double. For a TV commercial, more sketches are produced as a rule because there are usually more scene changes and more action than in longer films.

From *The Story of the Bible* by Halas and Batchelor. The storyboard drawings themselves are quickly done and easily replaceable, but contain all the essentials of the movement in each scene.

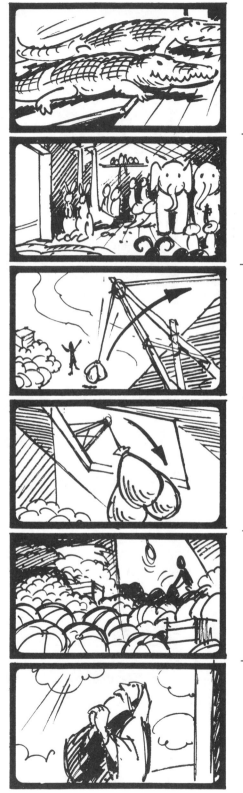

"THE FLOOD" (cont.)

Mix to top of ramp. Reptiles, etc., arrive.

" - of every kind of animal and of every kind - "

Track back to long shot crowded interior of ark.

" - of creature that moves along the ground will come to you to be kept alive."

Looking down shot. Sacks being raised on simple derrick.

"You are to take every kind of food - "

Interior of food store. Sacks descend.

" - that is to be eaten and store it - "

General shot interior of food store with vegetables, fruit, etc. Rope goes out.

" - away as food for you and for them."

Pan and track to medium close up of Noah outside doorway. Rainclouds gathering. Noah looks up to heaven with his hands clasped.

"Noah did everything just as God commanded him."

Fade out.

Responsibility of the director

The director is responsible for decisions regarding the overall pacing and planning of the whole story or a particular sequence of it.

This can involve sequences of several minutes' duration or of only a few seconds. He must also decide how these sequences should be organised into scenes.

How long should each scene be? What should be the pace of the action in the scene? What should be the pace of the action in order to hold the interest of the audience? How can ideas in the story best be put over to the audience? These are the problems the director must solve. Going down to yet shorter periods of time, to individual actions, the responsibility is shared between the director and the animator. But the director still has overall control.

The animator should, however, add some ideas of his own as to how certain effects can be achieved—just as an actor would in live action. The smallest units—individual drawings and frames—are almost entirely the animator's province, and this is where his particular skill lies. How does a ball bounce? How does a character react in surprise, or snap his fingers? These are problems the animator must solve by his feeling for and knowledge of the subject.

An animated film usually takes a long time to produce. During this period it is essential that the director should keep a constant check on how the production is progressing and how closely the original timing and concept have been followed.

Most animated films are made to a predetermined length. A TV commercial must be an exact number of frames and a longer film will probably have to fit between fairly narrow limits. One of the director's problems is to fit the action to the time available.

First divide the story into sections or sequences of convenient lengths. Run through each section mentally as many times as necessary to absorb all the important story points. Then run through each section again, timing it mentally with a stop watch. Add up all the timings to give an overall total. This is sure to be more or less wide of the mark. If it is fairly close, see whether a sequence can be adjusted to bring the total about right. If it is *much* too short, more business must be invented to fill the time available. If it is *much* too long, maybe a whole sequence must be omitted.

An example of a short TV commercial timed to a predetermined length. Timing decisions must always be made before the start of production.

From *Chappies*, a 15 second TV commercial by Halas and Batchelor for Bates-Wells-Rostron.

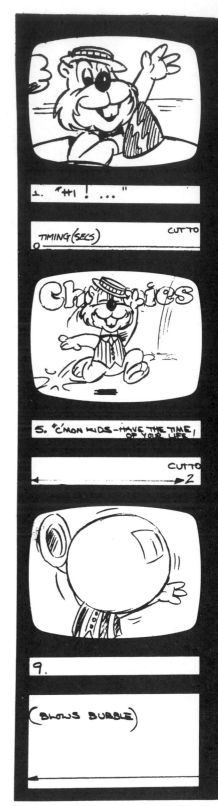

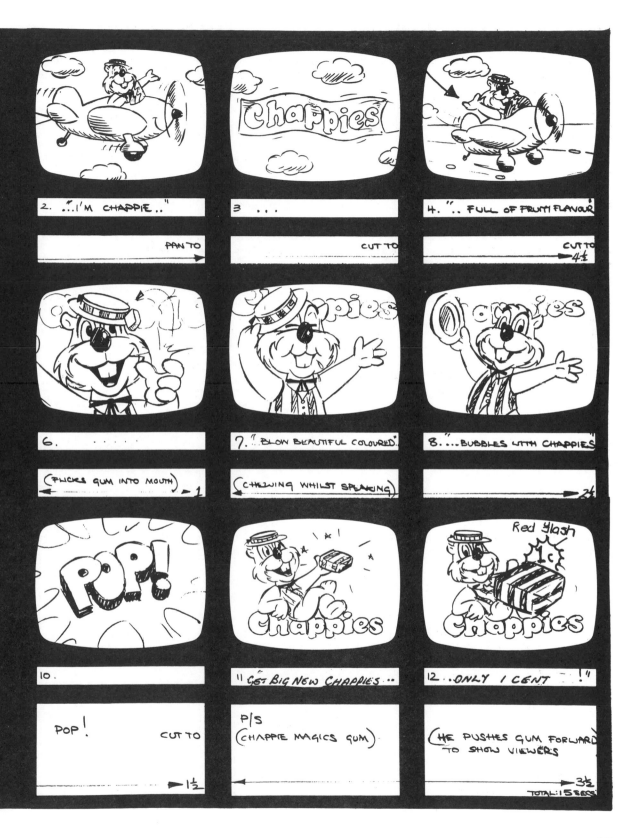

The basic unit of time in animation

The basis of timing in animation is the fixed projection speed of 24 frames per second. On television this becomes 25 frames per second, but the difference is usually imperceptible.

If an action on the screen takes one second it covers 24 frames of film, and if it takes half a second it covers 12 frames and so on.

For single frame animation, where one drawing is done for each frame, a second of action needs 24 drawings. If the same action is animated on double frames, where each drawing is photographed twice in succession, 12 drawings are necessary but the number of frames and hence the speed of the action would be the same in both cases.

24 frames of film go through the projector every second (25 on television). This fixed number of frames provides the basis on which all actions are planned and timed by the director.

Whatever the mood or pace of the action that appears on the screen, whether it be a frantic chase or a romantic love scene, all timing calculations must be based on the fact that the projector continues to hammer away at its constant 24 frames per second. The unit of time with which an animator works is, therefore, ¼₄ sec and an important part of the skill which he has to learn is what ¼₄ sec 'feels' like on the screen. With practice he also learns what multiples of this unit look like— 3 frames, 8 frames, 12 frames and so on.

Timing on bar sheets

When the director has given some thought to the overall timing of a film, he proceeds to more detailed timing and puts this down on paper on specially printed bar sheets. These are much like music manuscript paper, with several horizontal lines having spaces for dialogue, sound effects, music and action. He is concerned with timing the action and this is entered in the spaces very much as music is written, but in a kind of animator's shorthand.

The horizontal lines of the bar sheet are marked in frames with heavy lines marking every foot, that is, every 16 frames. The footage divisions on the required number of bar sheets are then numbered for the length of the film, and the timing of the action is ready to begin. If there is prerecorded music or dialogue to which the action must fit, this is charted before-hand from the soundtrack and entered into the appropriate spaces on the bar sheets.

People have their own individual shorthand, but generally a horizontal line means a hold, a curve means an action of some sort, a loop means the anticipation to an action, a wavy line means a repeat cycle and so on. If an action must take place on a certain frame, this is marked with a cross on the required frame. The action is also written out verbally with stage directions, repeat animation instructions and other relevant information.

Before production of an animated film starts, the director works out the timing of the film on bar sheets. He decides on scene continuity, the exact length of each scene and what action takes place within it. He also plans the pace of the storytelling and decides where tracks, pans, mixes etc, are needed to put the story over in the best possible way.

PRODUCTION NO. C 496 SHEET NO. ①

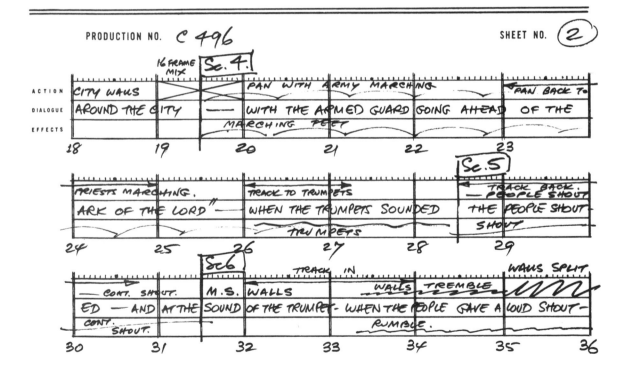

Sc. 1 16 FRAME F/I TRACK DOWN → **Sc. 2**

ACTION | L.S. JOSHUA ADDRESSING CROWD | MEN LIFT ARK TRACK BACK
DIALOGUE | SO JOSHUA SAID TO THEM — "TAKE UP THE ARK OF
EFFECTS |

0 1 2 3 4 5

CONT. TRACK → ← PAN TO PRIESTS →

THE COVENANT OF THE LORD AND HAVE SEVEN PRIESTS WITH TRUMPETS IN FRONT

6 7 8 9 10 11

Sc 3

C.U. JOSHUA POINTS ← PAN TO CITY. | M.S. CITY WALLS

OF IT" — AND HE ORDERED THE PEOPLE — "ADVANCE" ——— "MARCH

12 13 14 15 16 17 18

═══════════════════════════════════

PRODUCTION NO. C 496 SHEET NO. ②

16 FRAME MIX **Sc. 4.**

ACTION | CITY WALLS | PAN WITH ARMY MARCHING | PAN BACK TO
DIALOGUE | AROUND THE CITY | ——— WITH THE ARMED GUARD GOING AHEAD OF THE
EFFECTS | MARCHING FEET

18 19 20 21 22 23

Sc.5

PRIESTS MARCHING. | TRACK TO TRUMPETS → | ← TRACK BACK. — PEOPLE SHOUT

ARK OF THE LORD" — WHEN THE TRUMPETS SOUNDED THE PEOPLE SHOUT →
 TRUMPETS SHOUT

24 25 26 27 28 29

Sc 6 TRACK IN WALLS SPLIT.

← CONT. SHOUT. → | M.S. WALLS | WALLS TREMBLE
ED — AND AT THE SOUND OF THE TRUMPET — WHEN THE PEOPLE GAVE A LOUD SHOUT —
CONT. SHOUT. RUMBLE.

30 31 32 33 34 35 36

21

Timing on bar sheets is an extremely skilled operation. The director needs a great deal of experience to time out a film mentally before any drawing is done. When he commits his ideas to paper on the bar sheets, he is telling the story in terms of film, that is, cutting, timing and pace (movement).

He must run forwards and backwards through the story many times in his mind, relating the different parts of the story to one another in terms of dramatic flow. At the same time, he must be trying continually to judge what the effect will be on an audience who come fresh to it and who see the film through once only.

At the beginning of the film the director knows what is about to happen but the audience does not. The timing at the start of a film is, therefore, probably rather slow until the audience has been introduced to the location, the characters and the mood of the film. Once this has been done the pace may build up to the climax if it is a short film. If it is a longer film it may build up to a series of climaxes.

The bar sheets can also be useful in that having defined the complete continuity of the film, with scene lengths and other information, they can also serve as the basic reference for the composer, and for the editor when the final film is assembled.

Part of a production breakdown chart. After the director has decided on the timing, scene continuity and so on, this information is transferred to a chart showing scene numbers, footages, background numbers etc. As scenes are passed out and completed, boxes are shaded in on this chart so that the state of production can be seen at a glance.

REMARKS	ANIM. NAME	SC. NO.	DESCRIPTION	FTGE.	ANIM.	C.U.	B.G.
			PROD. NO. C·854 **NAME** PART A. **CLIENT**				

REMARKS	ANIM. NAME	SC. NO.	DESCRIPTION	FTGE.	ANIM.	C.U.	B.G.
	ED	1	F/I. L.S. INT. THEATRE — TRACK IN	7-0	■		1
	ED	2	C.U. SAM ANNOUNCES J.S — PAN TO ROBOT	7-0	■		2
STOCK ?	ED	3	C.U. ROBOT DOES ROUTINE (RIPPLE MIX)	13-8	■		3
	DS	4	M.S. MIKE & MARLON IN JUNK-FILLED WORKSHOP.	8-8	■		4
	DS	5	C.U. MARLON WITH WOODEN MALLET.	4-4	■		5
	DS	6	C.U. MIKE - PUZZLED	3-4	■		5
S.A.5	DS	7	C.U. MARLON	2-0	◤		5
	DS	8	M.C.U. MIKE & ROBOT -HE POINTS - "WHAT IS THAT?"	3-8	╱		5
PAN	DS	9	M.C.U. MARLON & ROBOT — TRACK IN & PAN ALONG ROBOT.	14-0	╱		5 OL9
S.A.5	DS	10	C.U. MARLON	3-0	◤		5
S.A.6	PJ	11	C.U. MICHAEL FEIGNS INTEREST	9-8			5
S.A.5	DS	12	C.U. MARLON	5-8	◤		5
S.A.6	PJ	13	C.U. MIKE — NOT INTERESTED	4-0			5
	PJ	14	C.U. MIKE'S POCKET. -MICE POP UP - AND DOWN	8-0			14
S.A.6	PJ	15	MIKE LOOKS UP WITH INTEREST.	3-0			5
	PJ	16	C.U. ROBOT. - MIKE'S HAND IN & POINTS	8-0			5 OL9
S.A.6	PJ	17	C.U. MICHAEL. -REALLY DELIGHTED.	6-8			5
S.A.5	DS	18	C.U. MARLON DOORBELL EFX. (OFF)	3-8	◤		5
S.A.6	PJ	19	C.U. MIKE TURNS & GOES OUT.	5-8			5
	ED	20	EXT. FRONT DOOR. -C.U. MIKE POPS OUT - TRACK TO INCLUDE SAM	11-0	╱		20
	ED	21	C.U. SAM RAISES HAT —LEANS FORWARD	5-8	╱		20

Exposure charts

When the director has completed the bar sheets for a film, the information is split up scene by scene ready for distribution to the animators.

The timing is transferred to printed exposure charts (known as dope sheets in the USA). Some studios use charts with units of 4 seconds (96 frames) on each sheet. Others who primarily work in television where the speed of projection is 25 frames per second, use sheets in 100 frame units which provide 4 seconds of running time for television.

Animation timing is usually indicated by the director in the left column of exposure charts, so that the animator can work out the number of drawings required to complete each action in the other columns. This information is useful to all members of an animation unit; the animators, their assistants and the cameraman. Alongside the production of animation, the exposure charts are filled in according to the levels of celluloids to be photographed and eventually serve as guides for photography.

Part of a completed exposure chart for an individual scene. Each horizontal division represents one frame of film. The director's timing is in the lefthand column and the camera instructions are on the right. The animator has written the numbers of his drawings in the middle six columns.

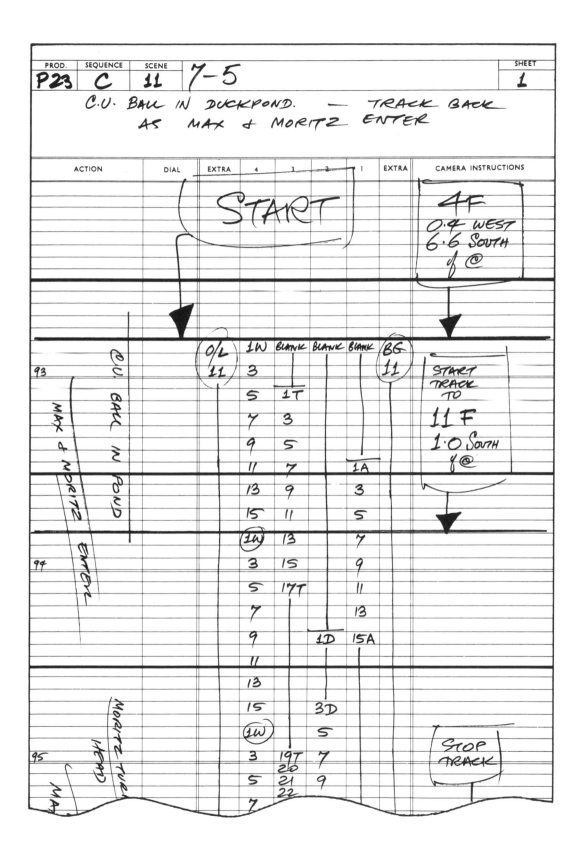

PROD.	SEQUENCE	SCENE	7-5	SHEET
P23	C	11		1

C.U. BALL IN DUCKPOND. — TRACK BACK
AS MAX & MORITZ ENTER

ACTION	DIAL	EXTRA	4	3	2	1	EXTRA	CAMERA INSTRUCTIONS
				START				4F 0.4 WEST 6.6 SOUTH of @
		O/L 11	1W BLANK	BLANK	BLANK	BG 11		START TRACK TO
93		3						
		5	1T					11F
		7	3					1.0 SOUTH
		9	5					of @
		11	7		1A			
		13	9	3				
		15	11	5				
		(1W)	13	7				
94		3	15	9				
		5	17T	11				
		7		13				
		9		1D 15A				
		11						
		13						
		15		3D				
		(1W)		5				STOP TRACK
95		3	19T 20	7				
		5	21	9				
		7	22					

C.U. BALL IN POND

MAX & MORITZ ENTER

MORITZ TURNS (HEAD)

MAX

Animation and properties of matter

The basic question which an animator is continually asking himself is: 'What will happen to this object when a force acts upon it?'. And the success of his animation largely depends on how well he answers this question.

All objects in nature have their own weight, construction and degree of flexibility, and therefore each behaves in its own individual way when a force acts upon it. This behaviour, a combination of position and timing, is the basis of animation. Animation consists of drawings, which have neither weight nor do they have any forces acting on them. In certain types of limited or abstract animation, the drawings can be treated as moving patterns. However, in order to give meaning to movement, the animator must consider Newton's laws of motion which contain all the information necessary to move characters and objects around. There are many aspects of his theories which are important in this book. However, it is not necessary to know the laws of motion in their verbal form, but in the way which is familiar to everyone, that is by watching things move. For instance, everyone knows that things do not start moving suddenly from rest—even a cannonball has to accelerate to its maximum speed when fired. Nor do things suddenly stop dead—a car hitting a wall of concrete carries on moving after the first impact, during which time it folds itself rapidly up into a wreck.

It is not the exaggeration of the weight of the object which is at the centre of animation, but the exaggeration of the tendency of the weight—any weight—to move in a certain way.

The timing of a scene for animation has two aspects:
1. The timing of inanimate objects
2. The timing of the movement of a living character

With inanimate objects the problems are straightforward dynamics. 'How long does a door take to slam?', 'How quickly does a cloud drift across the sky?', 'How long does it take a steamroller, running out of control downhill, to go through a brick wall?'.

With living characters the same kind of problems occur because a character is a piece of flesh which has to be moved around by the action of forces on it. In addition, however, time must be allowed for the mental operation of the character, if he is to come alive on the screen. He must appear to be thinking his way through his actions, making decisions and finally moving his body around under the influence of his own will power and muscle.

Animation consists of sequences of weightless drawings. The success of animation on the screen depends largely on how well these drawings give the impression of reacting in an exaggerated way when weight and forces are made to act upon them.

Movement and caricature

The movement of most everyday objects around us is caused by the effect of forces acting upon matter.

The movement of objects becomes so familiar to us that, subconsciously, these movements give us a great deal of information about the objects themselves and about the forces acting on them. This is true not only of inanimate objects, but also of living things—especially people.

The animator's job is to synthesize movements and to apply just the right amount of creative exaggeration to make the movement look natural within the cartoon medium.

Cartoon film is a medium of caricature. The character of each subject and the movement it expresses are exaggerated. The subjects can be considered as caricatured matter acted upon by caricatured forces.

Cartoon film can also be a dramatic medium. This particular quality can be achieved, among other means, by speeded up action and highly exaggerated timing. The difference between an action containing caricature, or humour or drama, may be very subtle. Eventually, with enough experience in animation timing, it becomes possible to emphasise the difference.

Caricatured matter has the same properties as natural matter, only more so. To understand how cartoon matter behaves it is necessary to look more closely into the way matter behaves naturally.

Cartoon is a medium of caricature—naturalistic action looks weak in animation. Look at what actually happens, simplify down to the essentials of the movement and exaggerate these to the extreme.

ACTUAL

CARTOON

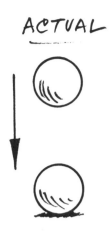

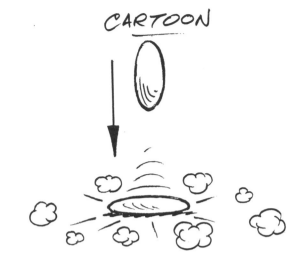

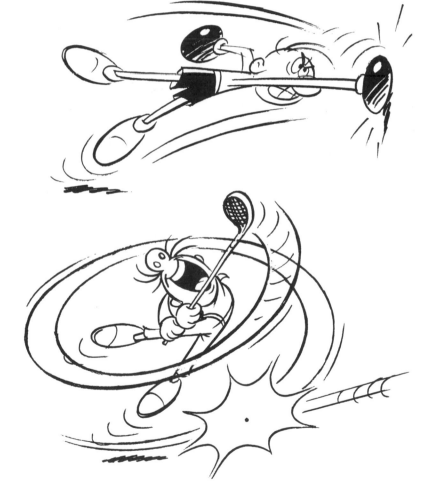

Cause and effect

There is a train of cause and effect which runs through an object when it is acted upon by a force. This is the result of the transmission of the force through a more or less flexible medium (ie caricatured matter). This is one aspect of good movement in animation.

An animator must understand the mechanics of the natural movement of an object and then keep this knowledge in the back of his mind whilst he concentrates on the real business of animation. This is the creation of mood and conveying the right feeling by the way an action is done.

Examples of cause and effect:

Figs A and B
A rope wrapped around *anything* and pulled tight has the tendency shown. How far the reaction goes depends on:
 i the strength of the forces pulling the rope.
 ii the flexibility or rigidity of the object being squeezed.
Exaggerate the tendency.

Fig. C
On the seesaw, the end of the plank with the smaller stone tends to stay where it is to begin with because of its inertia, so bending plank D. A moment later it starts to accelerate and the plank springs back with the opposite curvature causing the stone to whizz out of the screen, E.

Fig. F
The man is bending over to pick up something. His reaction when pricked is:
 G A reflex jerk to remove his behind from the pin.
 H A look of surprise or horror as he turns to see what is happening.

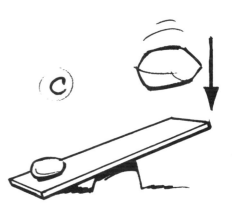

C A stone on one end of a seesaw.

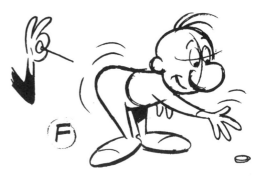

F A man stoops to pick something up.

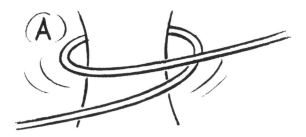

A A rope wrapped round something.

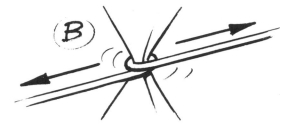

B The ends of the rope are pulled tight.

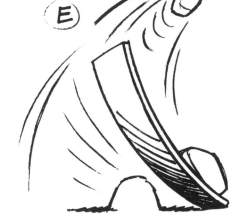

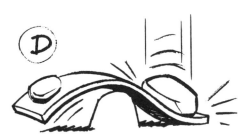

D and **E** A bigger stone drops onto the other end.

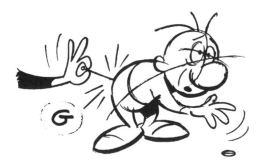

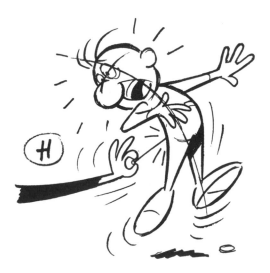

G and **H** He reacts when pricked by a pin.

Newton's laws of motion

Every object or character has weight and moves only when a force is applied to it. This is Newton's first law of motion. An object at rest tends to remain at rest until a force moves it and once it is moving it tends to keep moving in a straight line until another force stops it.

The heavier an object is, or strictly speaking, the greater its mass, the more force is required to change its motion. A heavy body has more inertia and more momentum than a light one.

A heavy object at rest, such as a cannonball, needs a lot of force to move it (Fig. A). When fired from a cannon, the force of the charge acts on the cannonball only whilst it is in the gun barrel. Since the force of the explosive charge is very large indeed, this is sufficient to accelerate the cannonball to a considerable speed. A smaller force acting for a short time, say a strong kick, may have no effect on the cannonball at all. In fact it is more likely to damage the kicker's toe. However, persistent force, even if not very strong, would gradually start the cannonball rolling and it would eventually be travelling fairly quickly.

Once the cannonball is moving, it tends to keep moving at the same speed and requires some force to stop it. If it meets an obstacle it may, depending on its speed, crash straight through it. If it is rolling on a rough surface it comes to rest fairly soon, but if rolling on a smooth flat surface, friction takes quite a long time to bring it to rest.

A A cannon ball needs a lot of force to start it moving. Once moving, it takes a lot of stopping.

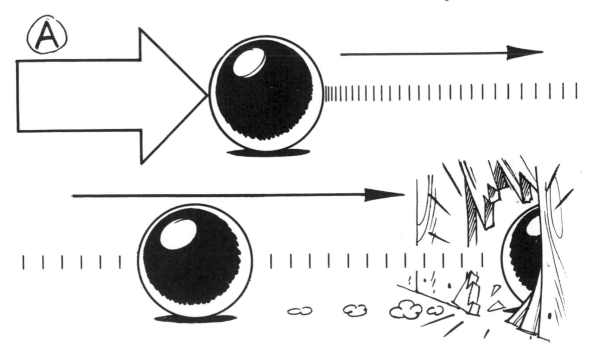

When dealing with very heavy objects, therefore, the director must allow plenty of time to start, stop or change their movements, in order to make their weight look convincing. The animator, for his part, must see that plenty of force is applied to the cannonball to make it start, stop or change direction.

Light objects have much less resistance to change of movement and so behave very differently when forces act on them. A toy balloon (Fig. B) needs much less time to start it moving. The flick of a finger is enough to make it accelerate quickly away. When moving, it has little momentum and the friction of the air quickly slows it up, so it does not travel very far.

The way an object behaves on the screen, and the effect of weight that it gives, depends entirely on the spacing of the animation drawings and not on the drawing itself. It does not matter how beautifully drawn the cannonball is in the static sense, it does not look like a cannonball if it does not behave like one and the same applies to the balloon, and indeed to any other object or character.

B A balloon needs only a small force to move it, but air resistance quickly brings it to rest.

In both these examples a circle is being animated. The timing of its movements can make it look heavy or light on the screen.

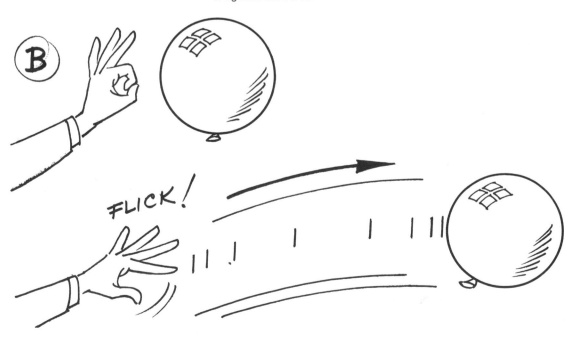

Objects thrown through the air

If an object is thrown vertically upwards, its speed gradually diminishes to zero (Fig. A). It then starts to accelerate downwards again. The height to which it rises depends on the speed at which it is thrown but the rate of deceleration is the exact opposite of the acceleration as worked out on page 37. In fact the same scale can be used for both acceleration and deceleration.

If a ball is thrown upwards at an angle, then its movement has two components, vertical and horizontal. Vertical speed diminishes to zero and increases again as it falls, whilst at the same time its forward movement remains fairly constant. This means the ball moves along a parabola (Fig. B).

If a rubber ball is thrown down on a hard smooth surface, it moves with a series of bounces. The curve between one bounce and the next is again a parabola. The parabolas diminish in height each time as some energy is lost by the ball on each bounce (Fig. C).

If possible, drawings around the actual bounce should be spaced as in Fig. C. The drawing after the squash should overlap the squash drawing slightly, as the ball accelerates to its maximum speed again. On the remainder of each parabola, the drawings tend to bunch together at the top and spread apart at the bottom of the curve, as in Fig. B.

If, when the ball is timed out at the required speed, there is a large gap between one drawing and the next, compared to the diameter of the ball, then it is a good idea to stretch the circle slightly into an ellipse in the direction in which the ball is travelling. This, possibly with speed lines added (see page 110) helps to lead the eye from one drawing to the next and smooth out the movement. This should not be overdone, however, particularly at slow speeds, as it may give a rather floppy effect to the ball.

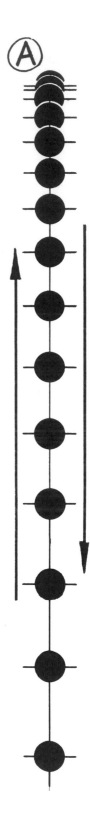

A The speed of a ball, rising vertically under the influence of gravity, gradually diminishes to zero. The same spacing of drawings can be used for its acceleration as it falls back to earth.

34

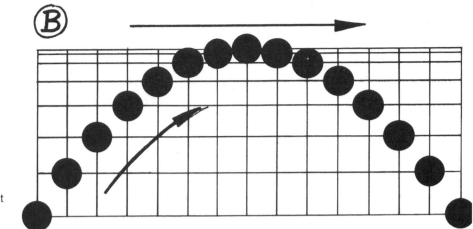

B If the ball is thrown upwards at an angle, it travels in a parabola.

C A rubber ball bouncing on a hard surface proceeds in a series of diminishing parabolas, as energy is lost on each bounce.

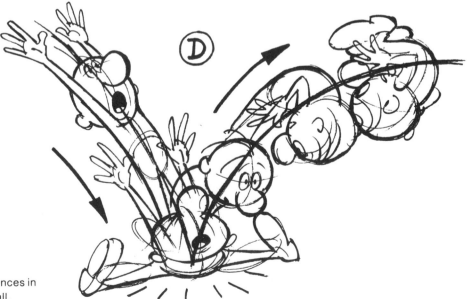

D A cartoon character bounces in much the same way as a ball.

Timing of inanimate objects

An inanimate object which has weight and is being acted upon by known forces moves in a predictable way. As a simple example, consider an object falling from rest under the influence of gravity. Disregarding air resistance, all objects fall with the same acceleration, which is about 9.8 metres per second per second. In practice, of course, the buoyancy of the air makes a leaf behave very differently from a lump of lead when dropped. However, assuming that an object is dropped which has an average weight, then the distance it falls in a time, 't', with an acceleration, 'f', is given by the formula:

$$\text{Distance} = \tfrac{1}{2}ft^2$$
$$= 4.9t^2 \text{ metres}$$

By substituting some numerical values for 't' distances fallen are as follows:

after $\tfrac{1}{8}$ second — 0.08 metres
$\tfrac{1}{4}$ second — 0.3 metres
$\tfrac{1}{2}$ second — 1.2 metres
1 second — 4.9 metres, and so on.

A graph with the time in frames plotted against the distance fallen, gives a parabola (see illustration). At a projection speed of 24 frames per second, the object falls as follows:

0.08 metres after 3 frames
0.3 metres after 6 frames
1.2 metres after 12 frames
4.9 metres after 24 frames, etc.

In animation it is not usually necessary to work out a movement like this mathematically. It is alright if it *looks right*, and it looks right if the movement is based on what actually happens in nature, simplified and exaggerated if necessary for dramatic effect.

Speed chart of an average object falling under gravity. The air resistance affecting the fall of a feather, or a heavy brick must be taken into account.

Disregarding air resistance, an object falling from rest accelerates at a fixed rate. If the distance fallen is plotted against the time taken it gives a parabola. The vertical scale on the right shows the distance fallen in a given number of frames. Starting from rest, whatever distance an object falls in a given time interval, it travels four times as far in twice that interval. For example, it travels four times as far in 18 frames as it does in 9.

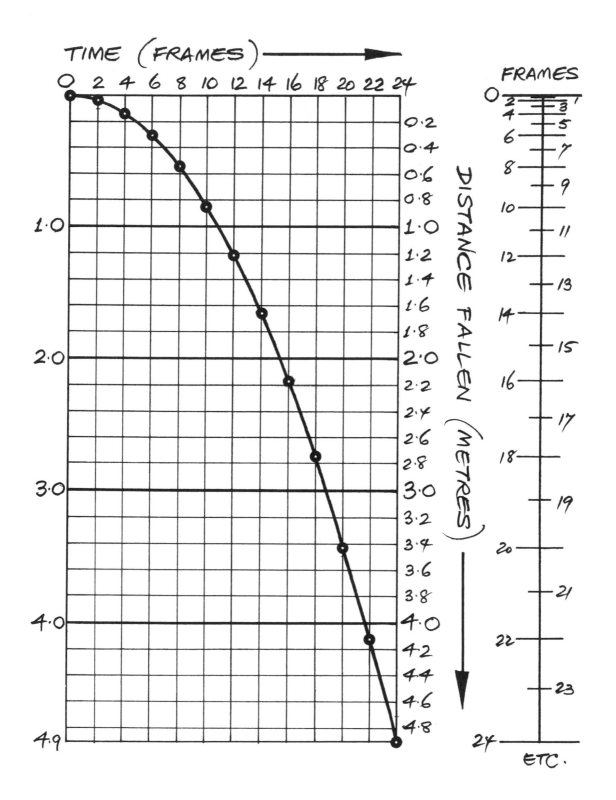

TIME (FRAMES) →

0 2 4 6 8 10 12 14 16 18 20 22 24

FRAMES

DISTANCE FALLEN (METRES)

0.2
0.4
0.6
0.8
1.0
1.2
1.4
1.6
1.8
2.0
2.2
2.4
2.6
2.8
3.0
3.2
3.4
3.6
3.8
4.0
4.2
4.4
4.6
4.8

1.0

2.0

3.0

4.0

4.9

0
2 | 1
4 | 3
6 | 5
8 | 7
| 9
10
| 11
12
| 13
14 | 15
16 | 17
18 | 19
20 | 21
22 | 23
24
ETC.

37

Rotating objects

To say that a bouncing or thrown ball travels along a parabola, really means that its centre of gravity does so. The mass of any body acts as though concentrated at its centre of gravity.

Irregular inanimate objects

If an irregular shaped object is falling or being thrown through the air, the movement of its centre of gravity along a parabola can be timed. As most objects have a tendency to rotate when flying through the air, the object is then drawn pivoting by a fixed amount about the successive positions of the centre of gravity along the parabola. For example, with a heavy hammer most of the weight is in the metal head and the centre of gravity is therefore close to this end. This would produce successive positions of the hammer as in the illustration (Fig. A). The shape of the hammer and the speed and direction of rotation might vary but the principle of movement remains the same.

In animation, if the speed of an object is sufficient, changes in perspective as the object rotates are not apparent. It is usually enough to have one drawing of the object with the position of the centre of gravity marked on it. This can then be placed with the centre of gravity over the required point on the parabola and traced off in this position. The centre of gravity is then placed over the next successive point on the parabola, turned through the required angle, and traced off on this position, and so on.

Animate objects—characters

In an object whose shape is variable, such as a man, the position of the centre of gravity also changes. If the man falls or jumps through the air, his centre of gravity also travels along a parabola (Fig. B), even though the shape of his body changes and he may rotate in much the same way as an inanimate object.

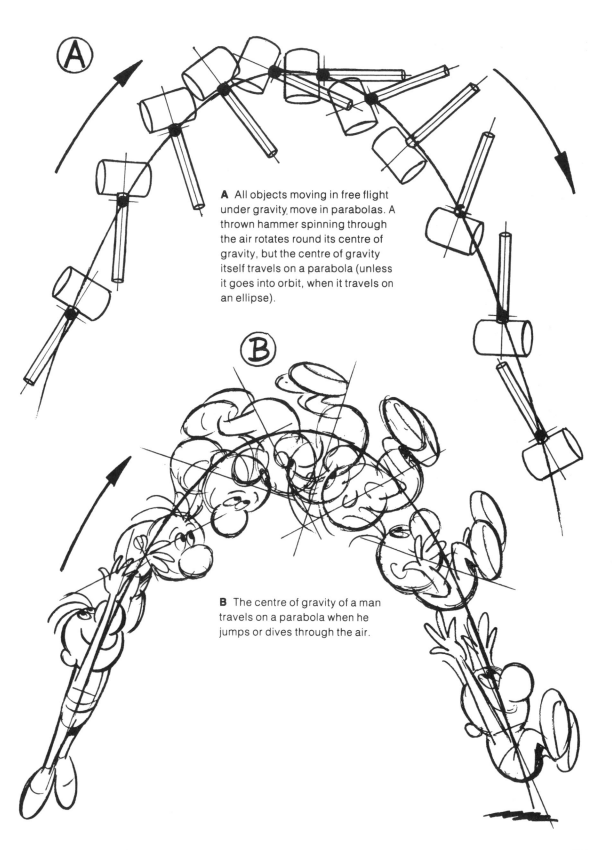

A All objects moving in free flight under gravity, move in parabolas. A thrown hammer spinning through the air rotates round its centre of gravity, but the centre of gravity itself travels on a parabola (unless it goes into orbit, when it travels on an ellipse).

B The centre of gravity of a man travels on a parabola when he jumps or dives through the air.

Force transmitted through a flexible joint

Imagine a length of wood with string fastened to one end of it, lying on a fairly smooth surface (Fig. A). Pull the stick towards the right, by means of the string, from a direction roughly at rightangles to the length of the stick. The first thing that happens is that the string pulls taut. Obviously the stick is not going to move whilst the string is slack. The weight of the stick acts as though concentrated at its centre of gravity, and so the stick as a whole does not start to move in the direction of the pull until its centre of gravity is in line with the string. So the stick rotates until the axis of the stick and the string are in line, and then moves off (Fig. B).

If instead of the string another stick is used, flexibly jointed to the first one (Fig. C), then something very similar to Fig. B occurs if the second stick is moved to the right. If the second stick (shown black) is now moved around as in Figs D and E, then the white stick moves more or less in the way shown, provided the joint is quite flexible. If the white stick is pushed around and is the prime mover, then the black stick behaves in a similar way to the white one in Figs D and E.

The main characteristic of these movements in animation is that when the primary stick accelerates or changes direction, the successive drawings of the secondary stick overlap each other as the stick rotates.

If three sticks are flexibly jointed together, and the lower stick is rocked to and fro fairly quickly, so that the effect of the momentum of the other two sticks becomes noticeable, the combined movement is similar to Fig. F.

The action of a force through a flexible joint

A to **E** The movement of a stick when a force is applied to it through a flexible joint. The white stick moves as a result of the movement of the black stick.

F The movement of three sticks flexibly joined together (drawings spread out side by side for clarity).

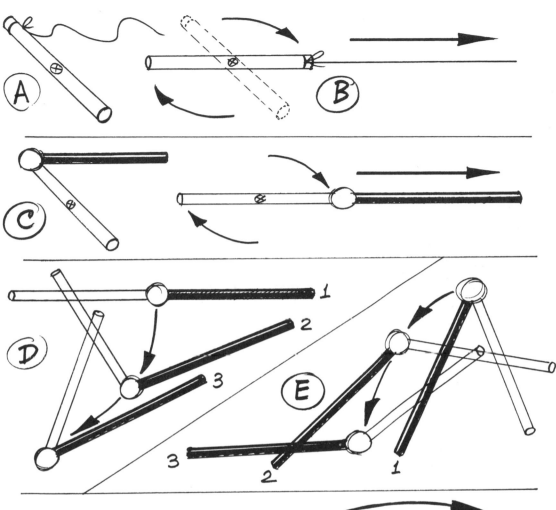

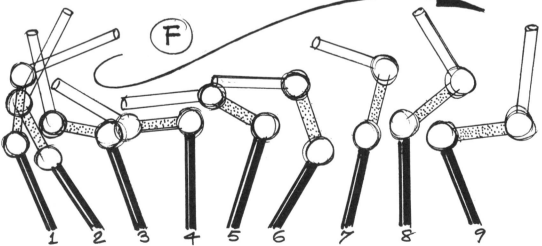

Force transmitted through jointed limbs

In character animation, force is very frequently transmitted by means of more or less flexible joints.

An animal or man can be thought of as a series of fairly loosely connected sections. A leg consists of the thighbone connected to a ball and socket joint at the hip; the lower leg, with a hinge joint at the knee; and the foot which is fairly flexibly jointed at the ankle. The arm is jointed from the shoulder in a similar way. So if a subject's shoulders are jerked backwards, his hands tend to follow only after his arms are pulled into line with the centres of gravity of his hands (Fig. A).

This is not strictly true, of course, with live characters because if the movement is slow enough, the muscles have time to contract and stop the arms straightening completely. Nevertheless the tendency is there, and it is these tendencies which the animator picks on and exaggerates. The faster the action, the greater the exaggeration.

Hands and feet move in the same way as the white rods on page 41. They tend to rotate on their centres of gravity when the direction of movement changes. In Fig. B, with a flexible wrist, the hand tends to trail backwards in the middle of a forward movement and in Fig. C the foot tends to trail in the direction it is coming from when the leg is lowered or raised and in Fig. D during a kick.

An object held loosely in the fingers behaves in a similar way when the hand is moved about (Fig. E).

How flexible joints are manipulated affects the animation of humans as well as animals.

A This is the equivalent in human terms of Fig. C on page 21.

B Note flexibility of wrist.

C and **D** Note flexibility of ankle as foot is lowered and raised, and during a kick.

E From the Hoffnung *Symphony Orchestra* showing movement of flexible arm and loosely held baton.

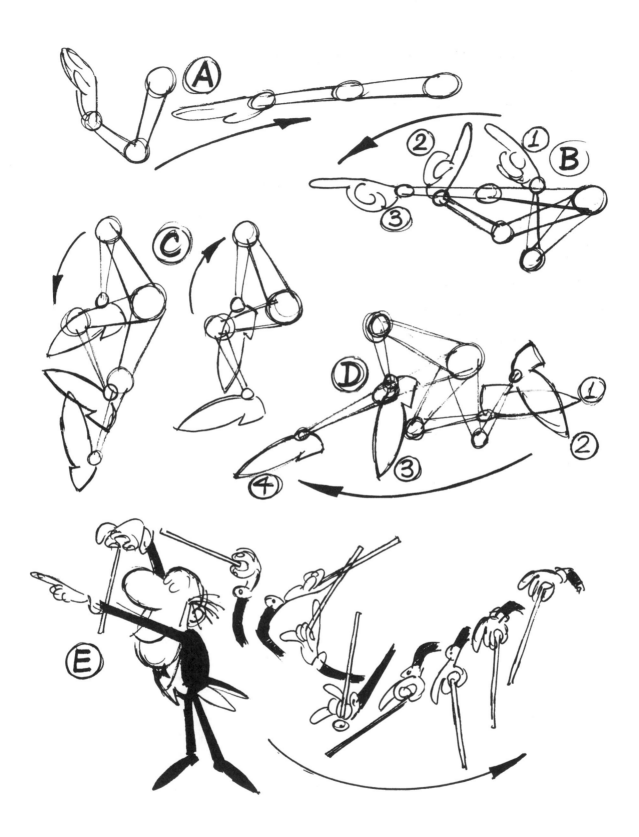

Spacing of drawings—general remarks

When any object in nature moves from a rest point X and stops at a point Y, it has a tendency, owing to the properties of matter, to accelerate to a maximum speed in the middle of the movement and then slow down to a stop (Fig. A). Obviously there are an infinite number of variations in detail, but this is the general tendency. A piston going to and fro moves more slowly at the ends of its movement and so in animation the drawings are closer together at the ends of the movement than in the middle. This kind of movement is called simple harmonic motion, and can be arrived at by projecting equidistant points on the circumference of a circle onto a straight line (Fig. B).

A An object moving from one point to another accelerates from rest to a maximum speed and then decelerates to a stop.

B The projection of the positions of a point moving round a circle on to a straight line gives the positions of a point moving up and down the line, with simple harmonic motion.

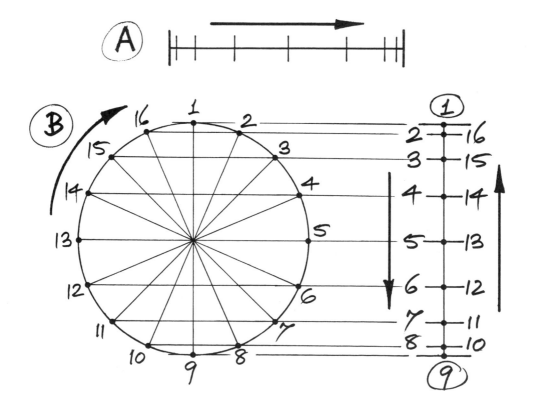

44

In animation it is sometimes difficult to graduate the space between drawings in this way and so usually an approximation is made by halving, rehalving and halving again the distance to be travelled, according to the time available. In some cases distances are split for convenience into thirds, or even quarters, although other proportions are usually impracticable (Fig. C).

A human figure moving to and fro, sawing for example, moves in a similar way to a piston. The body weight moves forwards, slows down, changes direction and starts to move backwards, slows down, changes direction, starts to move forwards, and so on. The general weight of the body moves forwards and backwards and the drawings are therefore spaced in the same way as those for a piston. The spacing of the drawings of the arm and saw are different from that of the weight of the body (see page 75) because the action of sawing requires manipulation of weight and muscle-power.

C Methods of inbetweening which are used in various combinations depending on the speed of the movement.

D A man sawing slows into and out of the two extremes of the movement (*see* also page 39).

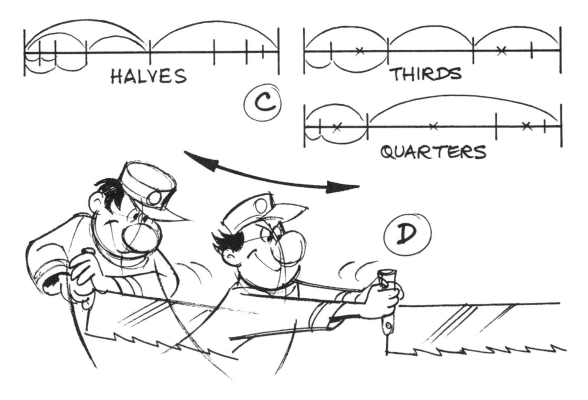

Spacing of drawings

As explained above, the basis of timing is the constant projector speed of 24 frames per second. If, therefore, something moves from A to B in 6 frames, the drawings required to do this are spaced twice as far apart as they would be if the object moved from A to B in 12 frames—assuming single frame animation is used in both cases.

Therefore, for an animator, the timing of an action is the same as deciding the number and spacing of the drawings needed to make up the action.

How many drawings are needed for example to make a character point his finger off screen? It is necessary to know a number of things to answer this. Is the character slow or quick in his reactions? Is he pointing, for example, to a distant view or is he pointing to warn somebody that a car is about to run him down? Is it a full arm movement or a more restricted finger movement?

If it is a fairly gentle movement, the action might take about 16 frames to complete which on double frame animation would be eight drawings. If the arm is at rest at the beginning and end of the movement, then the drawings are spaced more closely at the beginning and end. This gives the impression that the arm is a fairly weighty object accelerating from rest and decelerating again at the end of the movement.

A A simple arm movement, accelerating at the beginning and decelerating at the end.

B A more violent point. Drawings 1–5 anticipate the movement, the hand shoots out too far on 6–9 and returns to the final position on 10–12.

C A kicking donkey gives a more violent example of overshooting.

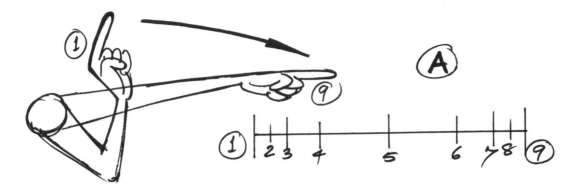

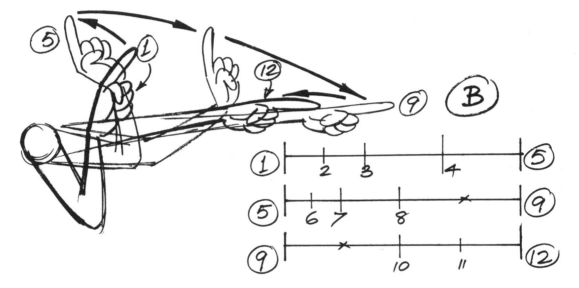

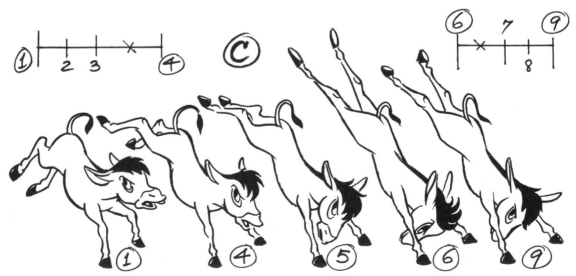

Timing a slow action

Occasionally it is necessary to animate movements which strain the medium to its limit, such as for slow movement. In a lyrical mood, slow motion or a comedy situation, this may be unavoidable. The closer drawings are to each other, the slower the movement appears. On the other hand, the wider the spacing between drawings, the quicker it looks on the screen. But there is a limit in both directions.

Closely spaced drawings tend to jitter if not drawn with great accuracy and if the distances are not worked out precisely. In cartoons, as a rule, very slow motion should be avoided. It is better left to live-action. If it must be done, make sure that the movement contains sufficient rhythm, bounce and flexibility. The drawings also need extremely careful tracing. Sometimes it is preferable to advance the animation by short camera dissolves rather than laboriously filling in every inbetween.

If the animated drawings are close and accurate enough, three or even four frame exposures are possible per drawing. In close up, however, this might appear too jerky. It is highly advisable to shoot an animation line test to ensure that the desired effect has been achieved.

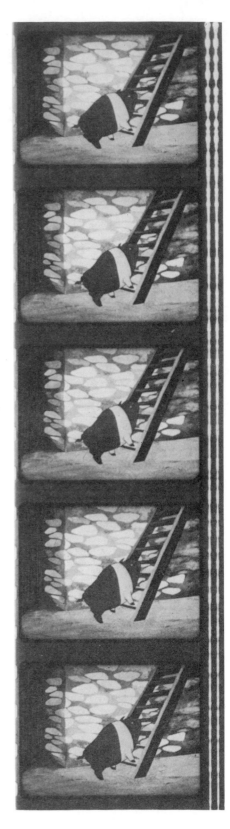

Enlarged film frames from *Animal Farm* showing an extremely slow movement of the character Napoleon ascending to the top of a barn on a ladder. Occasionally as in this case, it is permissible to apply 3 frames for each movement. The animation is so slow and the intervals are so close to each other that the movement does not appear jerky and the audience will not notice the difference.

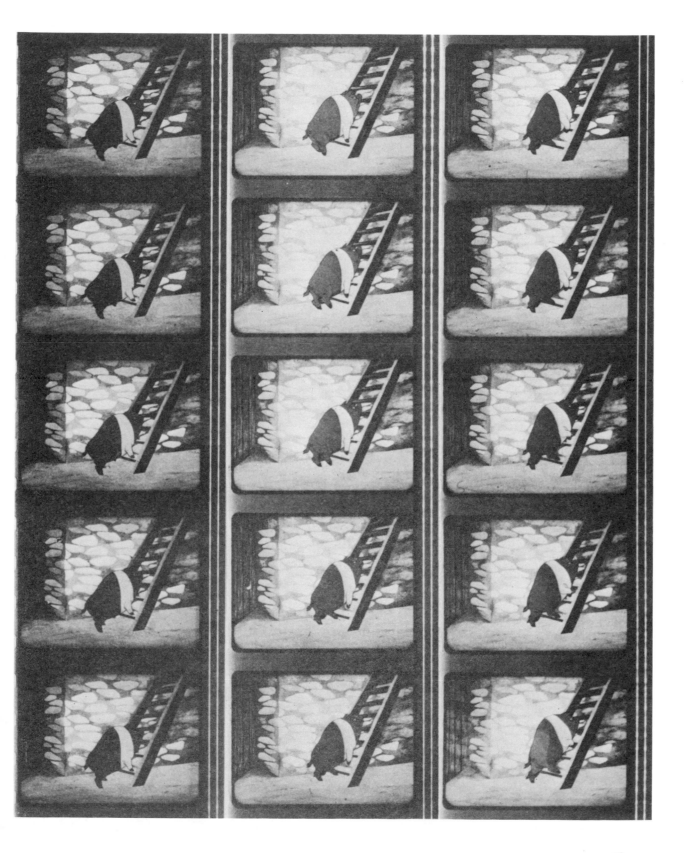

Timing a fast action

Fast rather than slow action suits animation best. It gives the animator an opportunity to create an illusion of pace and energy which is much more difficult to achieve with live action.

The important point to remember about timing fast action is that the faster the movement is, the more important it is to make sure the audience can follow what is happening. The action must not be so fast that the audience cannot read it and understand the meaning of it.

With fast action *anticipation* is very important indeed. The character prepares for the action he is about to do so that the audience is ready for the quick movement when it comes and

so can follow it even though it may be very rapid. In an extreme case, for example where a character zips off screen, the anticipation alone is sufficient and it is possible to miss out the zip altogether or perhaps dissolve it into a puff of smoke or 'whizz' lines (see page 111).

Of course there are times when anticipating *every* movement becomes tedious and it is necessary for dramatic effect to shock the audience with a surprise move. For example, if one character delivers a punch on the chin of another, it would be necessary to freeze the position of the fist at the end of the punch long enough for the audience to 'catch up' with what has happened. It might give more impact to shoot the fist out too far, bringing it back relatively slowly to the hold. This would give a bunching together of the drawings at the end of the punch which would make it easier to read.

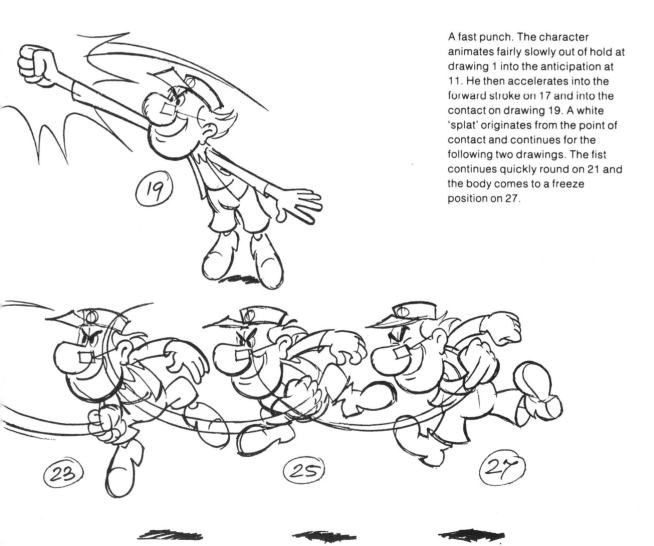

A fast punch. The character animates fairly slowly out of hold at drawing 1 into the anticipation at 11. He then accelerates into the forward stroke on 17 and into the contact on drawing 19. A white 'splat' originates from the point of contact and continues for the following two drawings. The fist continues quickly round on 21 and the body comes to a freeze position on 27.

Getting into and out of holds

The time it takes to reach a hold depends on the momentum of the object or character. A heavy man running takes several seconds to come to a stop, whilst someone leaning forward to listen simply slows into a stop.

Avoid having all parts of the figure coming to a stop at the same time. If a character jumps into a scene, for example, he might come in on an arc, squash, then recoil upwards too far before coming to rest in the final pose. Even after his body has stopped it may be effective to have his arms continue for another few frames. If the character has any loose extremities, such as coat tails or feathers in his hat, these must take some time to stop. These would probably be drawn on separate cel levels to allow for this. When a figure comes to a hold, any extremities which have been trailing behind keep on moving then settle back, perhaps too far, before coming to rest (see page 63).

If a character makes a quick movement of surprise or perhaps winces, which shows a rapid tightening up of the muscles or a reflex withdrawal from danger, then he must go into the hold quickly. If the hold is made slowly in this case, the feeling of surprise is lost. With a quick stop such as this, it is even more important to have an overlap on the movement of the arms or hair, for example, to soften the sudden stop.

When moving out of a hold, the spacing of the drawings usually gradually increases if the movement is fairly gentle. Any extremities hang back slightly until they are pulled along by the body. If the character goes into a more violent action, such as starting to walk, then the movement should be anticipated. The figure should draw back slightly before moving forward. As the front foot is raised the body begins to fall forward into the first step. If going into a run, the anticipation is more violent, with the body perhaps twisting away from the eventual direction of movement as the front foot is raised, and then leaning forward into the direction of movement so that the push on the back foot propels the body forwards.

A The character runs in and comes to a hold. He lands in a squash position and rebounds too high before coming to pose.

B To go into walk, he shifts his weight over his right foot so that he can lift his left foot, at the same time leaning into the direction of the walk.

C Here he moves from the same pose into a run cycle.

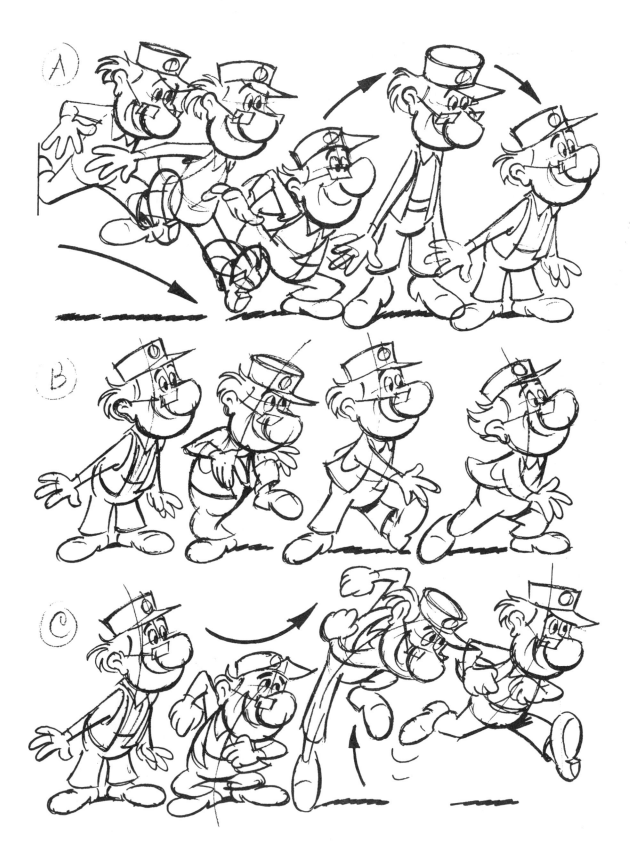

Single frames or double frames?

Most things can be animated sufficiently well on double frames to make the added expense of single frames unnecessary. Sometimes an effect does not work when double framing is used and then the extra drawings must be done. It is dangerous to animate on double frames during a table move and/or camera track. These moves are usually done on single frames for smoothness and the combination of doubles and singles can produce effects of 'jitter'. Animation done on pegs which move on single frames must also be animated on single frames (see page 134).

Broadly speaking and disregarding the above, the faster the action the more necessary it is to use single frames. In slow action, consecutive drawings are fairly close and the eye has no difficulty in jumping from one to the next but in fast action the timing may call for the drawings to be so widely spaced on

In timing a fast and continuous fluid action, inevitably single frame animation should be used. In the case of this quick dance fitted to a strong music beat of a folk or square dance, no other method would work. The figures turn 360° around and a very careful follow-through animation is essential to maintain the shapes of the figures. Once one cycle is animated, it is possible to repeat it several times.

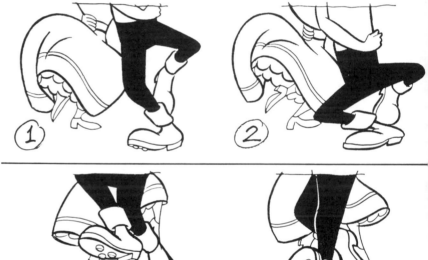

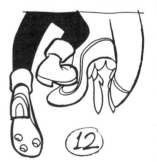

double frames that the eye can no longer connect them up. Animation on single frames obviously halves the distance between consecutive drawings when the action is at the same speed on doubles.

When an action is very quick it is sometimes impossible to put enough information into the animation at double frames to explain what is happening. In a very fast run, which may need a cycle of eight frames or four frames to a step, then double frame animation of two drawings per step just does not work on the screen. This, therefore, must be done on singles, giving four drawings per step, although even these may need drybrushing to make the action work.

Vibrating movements may also need single frames. A vibrating movement ABABAB etc, with two frames on A and B, gives a surprisingly slow reverberation, so if a more snappy result is needed, single frames must be used (see page 64).

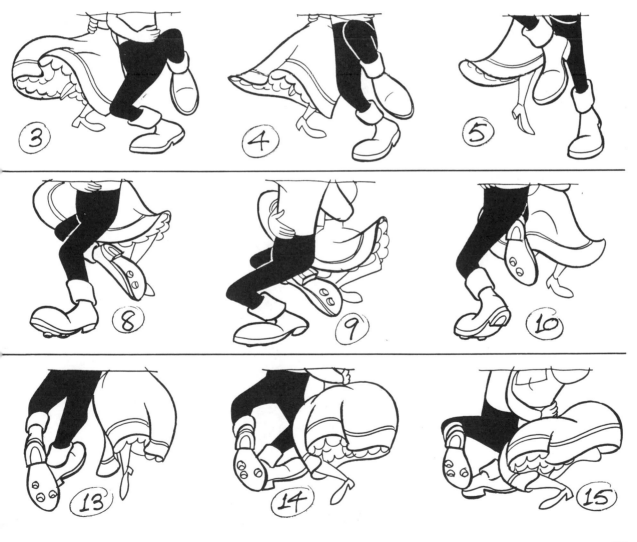

How long to hold?

The general question of how long to hold subdivides into two questions:

1. How long is it mechanically possible for the object to hold?
2. How long is it necessary to hold to give the best dramatic effect?

The first question applied to inanimate objects is simply a matter of whether the object is in stable equilibrium.

With a living character, the same point applies. Once he has arrived in a stable, fairly comfortable looking pose, he can hold it for ever. On the other hand he should not hold at all except for comic or other effect, in an off-balance pose. It does not matter how off-balance or awkward an extreme looks, provided it is reached properly and is moved out of fairly quickly. A drawing which works *as a hold* is really of a different kind from a normal animation drawing which works as one of a series. A held drawing can usually be extracted from the animation and works when framed and hung on the wall, whereas most animation drawings do not. A held drawing normally has a balanced look to it, although the subject can be either in a state of tension or relaxed. A relaxed or passive pose can be held for ever (listening, thinking, reading etc).

A A static gag, based on a joke drawing. The character raises the cymbals and holds there for 24 frames before a pan away to another member of the orchestra. (From *Symphony Orchestra* by Halas and Batchelor.)

D The 'freeze' position at the end of a fast throw, held for about 12 frames.

B The plug is held for 32 frames (with gurgling sound effect).

C The man stands up quickly and his body is held for 8 frames.

E A 'look' off screen needs a hold of about 12 frames before cutting to what the character sees.

F Allow about 16 frames for each word of a title card for reading time.

57

Anticipation

One of the tricks which an animator has to learn is how to attract the attention of the audience to the right part of the screen at the right moment. This is of great importance to prevent the audience missing some vital action and so the thread of the story. Although the audience is a group of individuals, the human brain works in a predictable way in these circumstances and it is possible to rely fairly confidently on reflex audience reaction.

If there are a number of static objects on the screen with the attention equally divided between them and suddenly one of the objects moves, all eyes go to the moving object about ⅕ second later. Movement is, in effect, a signal to attract attention. If, therefore, a preliminary movement is made before the main movement, such as drawing back the foot before a kick, the attention of the audience can be attracted to the foot. This ensures that they will see the kick when it comes.

The amount of anticipation used considerably affects the speed of the action which follows it. If the audience can be led to expect something to happen then the action, when it does take place, can be very fast indeed without them losing the thread of what is going on. If the audience is not prepared for something which happens very quickly, they may miss it. In this case the action has to be slower.

In an extreme case, if the anticipation is properly done, the action itself needs only to be suggested for the audience to accept it (see page 50). For instance, if a character is to zip off screen it is enough for him to draw back in preparation, followed by perhaps one or two drawings to start the forward movement. A few drybrush speed lines or a puff of dust can then imply that he has gone. These lines or dust should be made to disperse fairly slowly—probably in not less than twelve frames.

Since movement attracts the attention of the audience, their attention will be focused where motion takes place.

A Simple anticipation of a grab. This can be more or less exaggerated according to circumstances. The character moves from rest into the anticipation at 2, then into the grab position at 3.

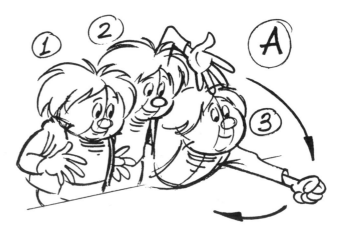

B A more violent movement
needing stronger anticipation.
This is on 2, before the main action
on 3.

Follow through

The animation of an extremity, such as a coat tail or a feather in the hat, is difficult to key at the same time as the character to which it belongs. Objects of this nature move to some extent independently of the character they are attached to. It is, therefore, difficult to predict where they will be a few frames ahead without following their movement drawing by drawing. The movement of an extremity depends on:

1. The action of the character.
2. The extremity's own weight and degree of flexibility.
3. Air resistance.

Imagine a dog with floppy ears which hang vertically when the dog is still. When the dog accelerates away the ears tend to stay behind but are pulled forward. As long as the dog does not slow down, the ears trail out behind, with a wave motion if the dog's head goes up and down. If the dog slows down and stops, the ears try to continue forward, and may stretch forwards before swinging backwards again and finally coming to rest. An attempt to key this movement with the dog is almost certain to fail. For instance, the ear may be moving at its fastest as the dog is coming to rest. Similarly, a cloak of heavy cloth moves independently as a result of the movement of the character's shoulders. It is important for the fluidity of the animation that the cloak is allowed to continue with its own speed and direction when the shoulders change their speed and direction. As a cloak is a large area, air resistance may be important too, particularly if the cloth is light. The movement of a gauze veil, for example, is governed almost entirely by air resistance, trailing behind the character and drifting slowly to rest after the character does.

To maintain fluid animation it is essential to treat the weight of a body differently from its accessories or extremities.

A A simplified dog's ear and its attachment to the dog. As the dog accelerates away the ear trails behind.

B When the dog stops, the ear tends to continue forwards at the same speed before swinging to rest.

C Cloth trails in a way which combines the effects of its weight and the air resistance.

D A horse's tail.

E A feather, which is more springy than the other examples.

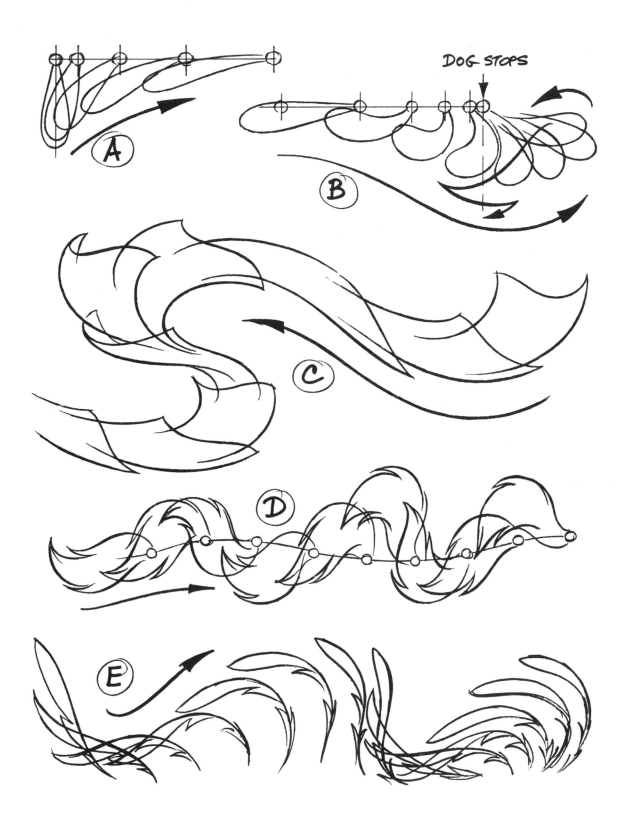

DOG STOPS

61

A A dog jumps in and stops. The front legs squash on 2 and the back legs on 4. The head and front legs are static on 5, although the back legs, tail and ears are still moving.

B–F Five balls bouncing. B, C and E are together; D is overlapped one frame late and F one frame early.

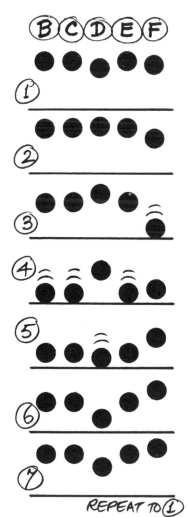

REPEAT TO ①

Overlapping action

It is usually a good idea in animation to have a time lag between the movements of different parts of the figure. This is called overlapping action. In a slow, gentle action this may not be necessary, but in a more violent movement it helps to give fluidity.

If several characters are dancing in unison on the screen, that is, using the same animation traced off several times, their movements look much more alive and fluid with an overlap of one or two frames on some of the characters. The result is that these characters are just out of sync with the others, which appears less mechanical than having them exactly in unison. Trained soldiers marching, when the effect should be rather machine-like, should of course be timed exactly together. For a squad of new recruits, however, a four frame overlap on some of them may not be enough to give a ragged look to their marching.

Imagine a dog running along and coming to a stop. The first thing to stop are probably his front feet, then his back legs and feet come up behind. As he has gone into a 'squash' onto the front feet at first, once all four feet are firmly on the ground he comes out of this and might even go up too high and settle back into the final pose. If he has floppy ears, these are probably the last things to come to rest.

The principle on which overlapping action is based, is really only that of momentum, inertia and action through a flexible joint as discussed on page 40. The reason it works so well in animation is that the natural tendencies of movement work in this way and these are picked up and exaggerated.

G A loosely rattling car can be built up, for example, in four drawings. The bonnet and the door can be keyed on the top scale, two wheels and one mudguard on the second scale, the steering wheel and the front bumper on the third scale, and so on. In this way the movement of each part of the car can be made to overlap with the part next to it as far as possible. The amount of movement depends on the circumstances.

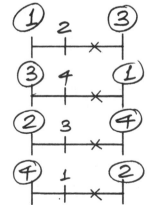

63

Timing an oscillating movement

A fast vibrating movement, such as a spring twanging, can be done as shown in Fig. A. The movement between the extremes is so fast that no in-between drawings are necessary. It is only necessary to show the extreme positions of the spring getting gradually closer to the rest position. The vibration of a larger and heavier object, such as a springboard just after a diver has left it, is timed more slowly, taking perhaps four frames to go from the bottom of the movement to the top. In any action in which the direction of movement reverses at an extreme, it tends to come out of the extreme more slowly than going into it. This gives more 'snap' to the movement. Cycles of less than six frames may look mechanical and it may be worth doubling the length of the cycle with two different variations of the movement or, instead of using a repeat of four frames, use a double near-repeat of seven or nine frames, so that the same positions do not appear on two consecutive repeats.

The other type of inanimate repeat is discussed on page 82, in which the force of the wind causes a wave to move along a flag. A similar movement takes place when an animal wags its tail. The tail-wagging muscles can be considered as acting directly on the part of the tail next to the animal's body causing the lower section of the tail to move from side to side. As the tail is flexible this movement is transmitted to the next, higher section with a slight time lag. The movement of this second section is then passed on with another time lag, and so on to the end.

A A vibrating spring, animated on single frames.

B The slower vibration of a springboard.

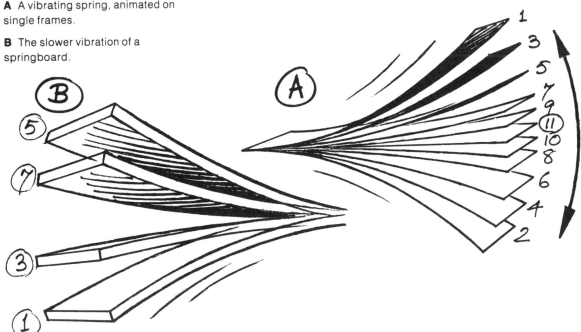

C A repeat cycle of an animal's tail wagging.

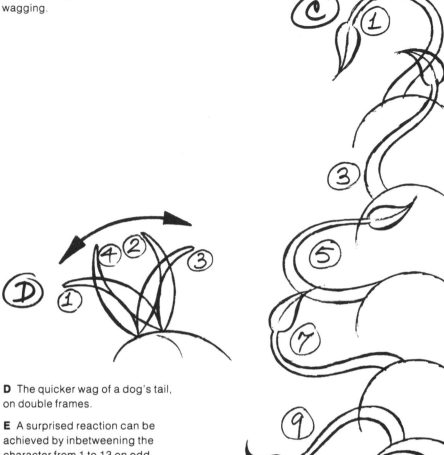

D The quicker wag of a dog's tail, on double frames.

E A surprised reaction can be achieved by inbetweening the character from 1 to 13 on odd numbers and from 2 to 13 on even numbers. If the drawings are shot consecutively a vibrating movement is achieved, coming to rest on 13.

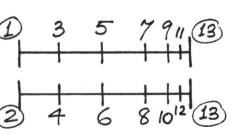

Timing to suggest weight and force—1

Each part of the body moves as a result of the action of muscles, or as a result of the movement of another part of the body to which it is attached. For instance in Fig. A, when the arm is raised, the upper arm tends to be raised first by the shoulder muscles. As the elbow is a flexible joint, there is a time lag before the forearm starts to move and similarly another time lag before the hand moves.

In a walk, the knee is a hinge joint and the ankle acts almost like a ball and socket joint. If the angle between the shin and the foot is kept the same, the ankle joint appears to be rigid, so this angle must vary. In Fig. B the foot starts on the ground (position 1) and is lifted forward for the step. The knee is raised, but the foot tends to hang back and so comes up heel first. The toe trails downwards until the top of the movement (position 4), but as the leg straightens the foot tends to keep going up and so, as the heel goes down, the foot rotates until the heel hits the ground (positions 5 and 6). The foot now tends to continue its downward movement but as it is stopped by the ground it quickly slaps down flat.

If, as in Fig. C, a character is to give a strong pull on a rope, the first part of the body to move is probably the hips, followed by the shoulders, the arms and finally by the rope. The amount of movement depends on the strength of the character, the weight on the other end of the rope and the

A Raising an arm, showing effect of flexible joints.

B In a walk the flexible ankle joint results in the foot trailing downwards as the ankle goes up on drawings 2 and 3, and trailing upwards as the ankle goes down on drawings 5 and 6.

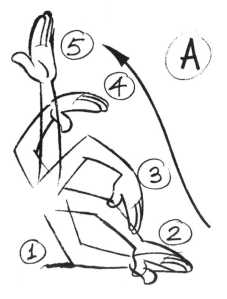

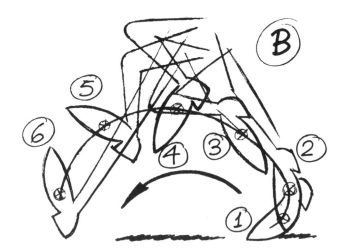

mood of the scene, but the order in which different parts of the movement take place is the same.

If, in the same situation, the character is being pulled by a force at the other end of the rope, as in Fig. D, then the order of events is reversed. First the rope moves, then the arm, the shoulders and the hips. The first part of the pull takes up the slack in the rope, and if the movement is fast, the shoulders do not move until the rope and the arms have been pulled into a straight line. At this point the shoulders jerk forward and the character tends to pull out into a straight line as he goes out of screen. In a slow, steady pull the character may have time to react and try to resist.

C The sequence of events when a man pulls on a rope. On drawing 2 he takes up the slack, on 3 he starts to move his body weight backwards and on 4 he leans back on the rope.

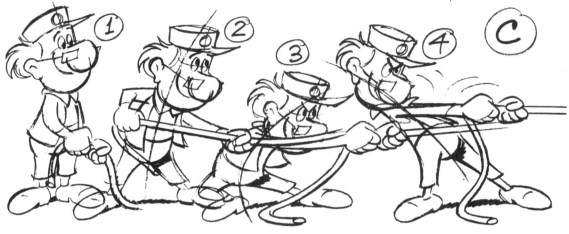

D When the rope itself is jerked, the man's arms are drawn forwards until they are in a straight line with the rope. At this point his shoulders are pulled forward in drawing 3 and in 4 and 5 his whole body is dragged away.

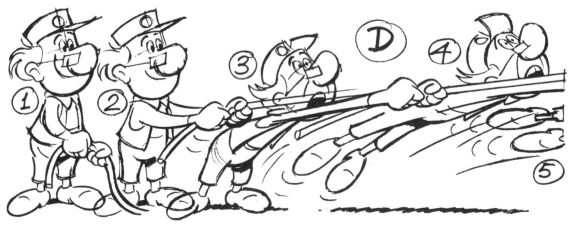

Timing to suggest weight and force—2

To give the impression that a character is wielding a heavy hammer it is important to time the movement carefully.

The start position is as Fig. 1. The man is relaxed with the hammer head resting on the peg which he is going to hit. To start the movement he lifts the hammer. If it is heavy, he cannot do this in the position shown in Fig. 1A as he would then be off-balance and would topple over. In order to transfer the weight of the hammer over his feet so that he is balanced, he must step forward and grasp the hammer near its head

To make the hammer look heavy, the man must keep the weight of the hammer head more or less balanced above his feet, until he hits the ground with it. Only a light hammer could be lifted, as in 1A, without the man falling over.

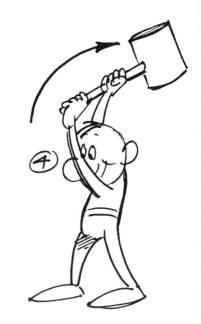

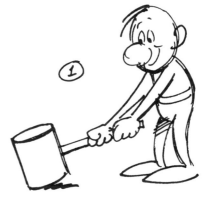

(Fig. 2). He can now slide the hammer towards himself and lift it above his widely-spaced feet (Fig. 3). As the head of the hammer rises above shoulder level, he starts to move its weight backwards in preparation for the forward action. However he cannot let it go too far behind him or he would overbalance backwards (Fig. 4). So he starts to move his body weight forward, and this eventually starts the hammer head moving forward (Fig. 5). He jerks his body forwards and downwards to give a forward impetus (Fig. 6) and the job is done. Now he need only step back and the hammer will fall and hit the peg. This position links up to Fig. 1 or at least Fig. 2.

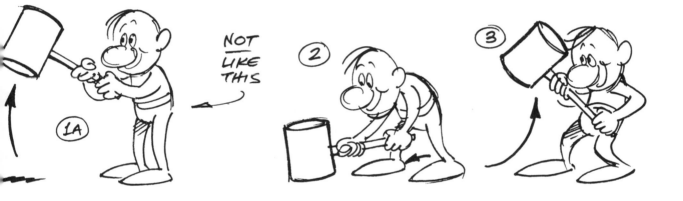

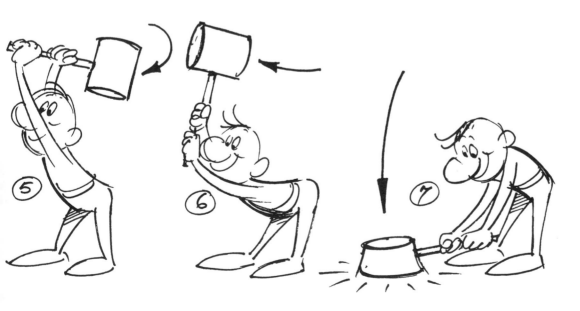

Timing to suggest weight and force—3

In an energetic, repeated movement, for example, a man hitting something with a pitchfork, the different parts of the figure move in a particular way to give the maximum feeling of effort.

Drawing 1 shows the impact of the pitchfork with the ground. The end of the pitchfork remains in contact with the ground for drawings 2–4, whilst the body begins to move out of the extreme position in readiness for the next stroke. The shoulders arrive at their furthest backward position in drawing 7 and begin to move forwards again in drawing 8, although the head of the pitchfork is still moving backwards. In drawing 9, the hips move quickly backwards as the shoulders and arms come forward and downwards, leaving a big gap between the position of the pitchfork in this drawing and that in drawing 1 to give a final impact to the movement. Note how the curvature of the body changes from convex to concave by means of 'S' curves on drawings 2 and 7.

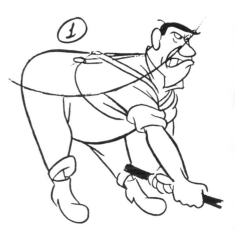

The man is repeatedly hitting something on the ground with a pitchfork. Note how the weight of the body is manoeuvred to get the maximum effort into the impact on drawing 1.

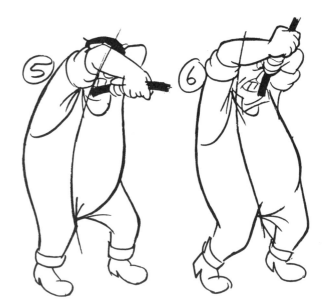

70

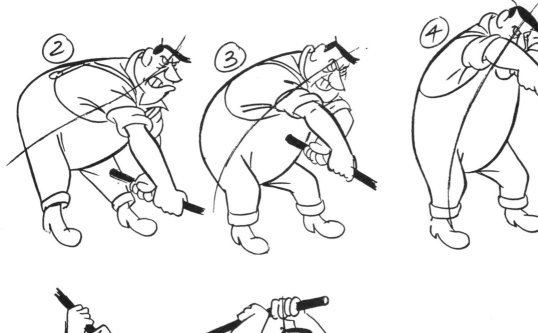

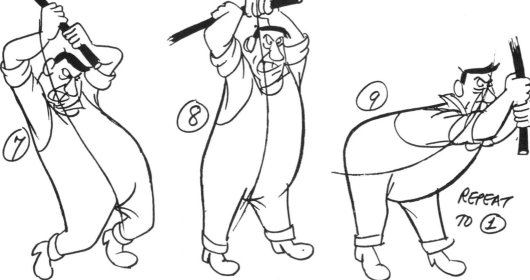

REPEAT
TO ①

Timing to suggest weight and force—4

An athlete is going to lift the heavy bar bell. He starts confidently, and in drawing 17 is anticipating grabbing the bar. He grabs the bar on 25, and 31 is the anticipation to the first attempted lift. He is still confident but grits his teeth somewhat as he makes the effort, as shown in drawing 37. The bar bell does not move. After 37 he comes to a puzzled hold as he realises he has a more difficult problem than he thought. In drawing 57 he makes a much bigger jerk after making a more determined and annoyed anticipation in drawing 51. After this jerk he manages to lift the bar bell with great difficulty. A few frames after drawing 65 he collapses out of screen under the weight.

On drawing 17 the athlete confidently prepares to lift the heavy bar bell. He anticipates on drawing 31 and tries to lift on drawing 37. The weight does not move so he makes a much bigger anticipation on drawing 51 and a big jerk on drawing 57, which enables him to get the weight up in the air on drawing 65, before collapsing with exhaustion.

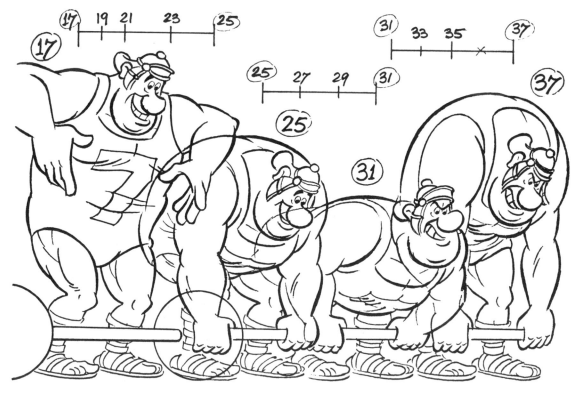

72

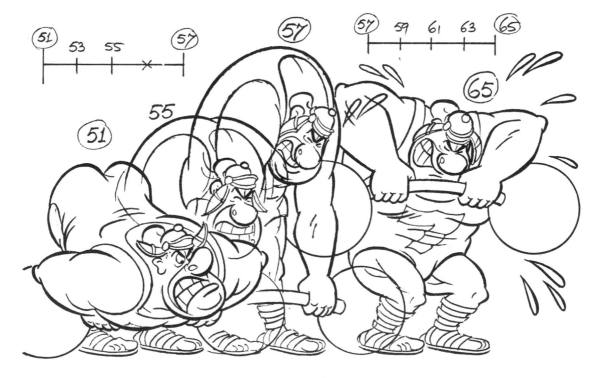

Timing to suggest force: repeat action

In a repetitive to and fro action such as sawing, it is not sufficient to draw the forward and backward extremes and then inbetween them. To convey the feeling of effort being put into the action it is necessary to analyse the relationship in time between the movement of the body weight, the muscles of the arm, and the action of the saw. This can be done by actual or mental miming. If a lot of effort is needed to push the saw through the wood, this cannot be supplied by the arm muscles alone, as straightening and bending the arm would move the shoulder back and forth as well as the saw. Immediately before straightening the arm, the whole body weight must be moved forward, so that when the arm does straighten it does so against the forward momentum of the body weight and so the thrust is applied to the saw. The thrust is increased by rotating the shoulders at the same time.

When sawing with the right hand the right shoulder is held back during the beginning of the forward body movement, then it is quickly brought forward, followed immediately by the straightening of the right arm, which puts the full effort of the movement into the action of the saw. On the return stroke, little effort is required in the movement of the saw, which cuts only on the forward stroke and so the sequence of events is less complicated. Some time lag between the backward movement of the body and the saw makes the animation more fluid, but otherwise straightforward inbetween drawings are sufficient.

In a repeated movement such as sawing, the action is basically forward and backward between 1 and 9. However, to give a feeling of effort, intermediate keys, 5 and 9, are also needed. Of these 5 is more important, as the weight of the body comes forward before the final thrust is given to the right arm.

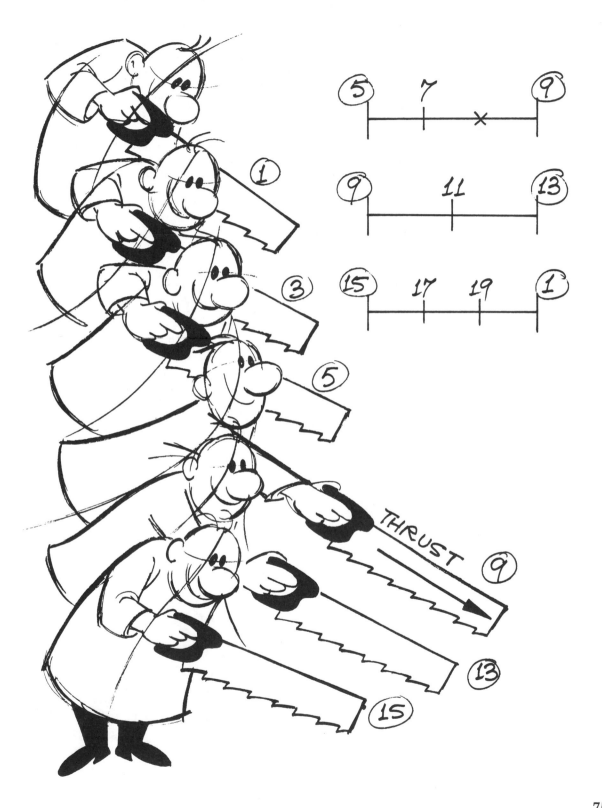

Character reactions and 'takes'

A further advantage which animation can claim over live action is the ease with which character reactions can be controlled and exaggerated. Without some degree of exaggeration, cartoon animation would not look right. The success of such effects lies in timing.

A character makes a 'take' when he suddenly sees or becomes aware of something which makes him react in surprise. There may be a short or long time lag between when the character sees whatever it is, and when the message gets through to his brain. This would be at least five frames, but could be a lot longer depending on the character's mental ability.

A Note that the action of surprise from drawings 1 to 13 is strengthened by a preparatory gesture in drawing 5 and an overshoot on drawing 9.

B Similarly this character's expression is underlined by key drawing 3 which drives home dramatically the surprise expressed in key drawing 7 which would hold for perhaps twelve frames. (From *Hamilton*, TV series by Halas and Batchelor.)

The first principle is to co-ordinate the character's body movement with his facial expression. The legs, arms, hands, the position of the body; all must contribute to a reaction. The facial expression must be emphasised with adequate exaggeration, particularly of the eyes and mouth.

In Figs A and B, both characters start with a hold on drawing 1, whilst the message is transmitted to the brain, then both go down to an anticipation or 'squash' position. They are then both animated up to a position beyond that in which they eventually come to rest. This 'overshoot' (Fig. A9 and Fig. B5) is the drawing which gives the feeling of surprise in each case, but the hold at the end (Fig. A13 and Fig. B7) is the drawing which the audience sees. The latter is, therefore, the one in which the face should project the character's full reaction.

There are, of course, differences of reaction according to the type of character portrayed. A big brainless character requires a longer time to react than a small excitable character. This is where character animation can excel on its own, and where the art of animation begins.

Timing to give a feeling of size

The way a movement is timed can contribute greatly to the feeling of size and scale of an object or character. When animating a man with naturalistic proportions, his movements may be timed as he would perform them in real life. If, however, he is to appear as a large giant, his actions must be retimed. As a giant he has much more weight, more mass, more momentum, more inertia; he moves more slowly than a normal man. He takes more time to get started and once moving takes more time to stop. In fact any changes of movement take place more slowly.

Conversely, a tiny character, such as Tom Thumb, has less momentum, less inertia than normal and so his movements tend to be quicker.

A and **B** The timing of the movements of the giant (A) would be very much slower than that of the mice (B). To make the giant appear large and heavy, we must allow plenty of time for him to get his weight moving. On the contrary the mice are tiny and light, so their movements would be quick and snappy.

In nature it is possible to gauge roughly the scale of an object as it falls. For instance, if a model car is filmed going over a cliff edge and it hits the ground half a second later, it is immediately obvious that this is a model car and the cliff is about 1.2 metres high. If the same action is filmed with a high speed camera and projected at normal speed, the car takes about four seconds to reach the bottom of the cliff. If there is nothing else to judge the scale by, the brain is then deluded into thinking that it is a full sized car, and that the cliff is about 80 metres high.

The action of flames is similarly affected by the scale of the fire. A small flame flickers quite quickly, whereas the flames of a large fire have a slower, wavelike movement (see page 46).

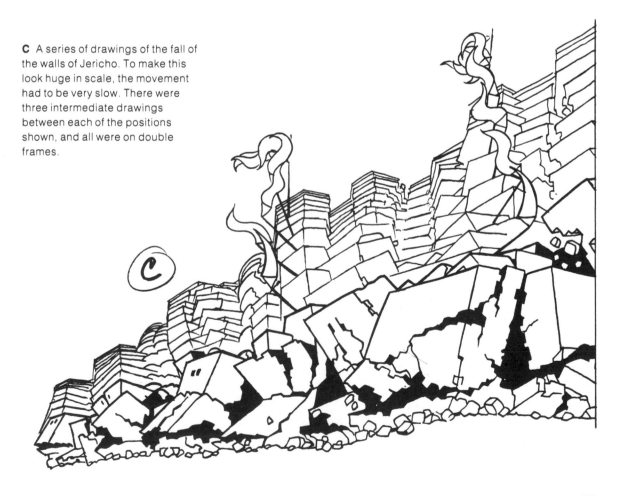

C A series of drawings of the fall of the walls of Jericho. To make this look huge in scale, the movement had to be very slow. There were three intermediate drawings between each of the positions shown, and all were on double frames.

The effects of friction, air resistance and wind

Imagine a cartoon elephant running along. He wants to make a sudden stop. How should he be animated? If he is on an ice rink it is difficult to see how he can stop. It might be possible to turn him round and make him work his legs as though running in the opposite direction. On ice, he would get little purchase and so this method would produce little result. If he is on a normal surface he can use the friction between the ground and his feet to slow himself down. The animator must, however, arrange the elephant's weight to be as far as possible behind his feet as he slows down. If he was upright, the friction would slow down his feet, but the upper part of his body would continue moving quickly and he would fall forwards. So his body must lean backwards. He might go into this position with a slight jump to achieve the maximum effect of his weight bearing down onto his feet. With his back foot covering the maximum area of ground for friction and his front heel ploughing into the ground for maximum braking effect, he can stop quickly. As he stops he must bring his body upright to avoid falling backwards.

Similarly, if a man applies the brakes suddenly in a motor car it may be effective to draw the car in a backwards leaning position, with the tyres squashed so that they have as large an area as possible in contact with the road. If the hubs press forward against the tyres whilst the friction from the road surface stretches them backwards and the driver leans back pulling on the brake lever, a good effect should result.

Wind is a useful device to give life to an animated object. It can very occasionally be animated as drybrush but is usually shown by its effects. Leaves are swept along, trees bend and wave according to the wind speed, and so on. Moving air flows and eddies around objects in much the same way as water does. Light objects, such as dead leaves, are swept along more or less at wind speed in curves and eddies.

There is usually an area of calm air in the lee of a solid object in which windswept material collects. Driving snow does not make a drift until the wind meets an object such as a wall. The snow is then deposited against the wall.

Anything fairly flexible, such as a plant or a tree, has its own natural vibration period, depending on its length, like an inverted pendulum. When blown by gusty wind, such an object tends to sway in this natural rhythm. A tall tree might sway to and fro in two or three seconds and a plant in less than one second.

The speed and mood of the wind is also well shown by curtains, waving flags and clothing, the animation of which can be graduated from a slow, languorous wave to a violent, rapid flutter as the cloth strains to tear itself from its support.

A The elephant is trying to apply as much friction as possible to slow himself down on a slippery surface. He keeps his weight low down as he leans backwards and digs his front heel into the ground.

B A possible distortion caused by an extreme tyre skid. The car and the axle tend to continue forwards, whilst the tyre and the wheel hub are pressed backwards by the friction of the ground.

C A spinning car wheel throws up dirt, mud, etc, because of friction.

D Air resistance causes the extremities of the witch, ie the hat, feet, etc, to bend backwards. Her long hair and clothes flow in the wind in a series of waves (*see* page 83).

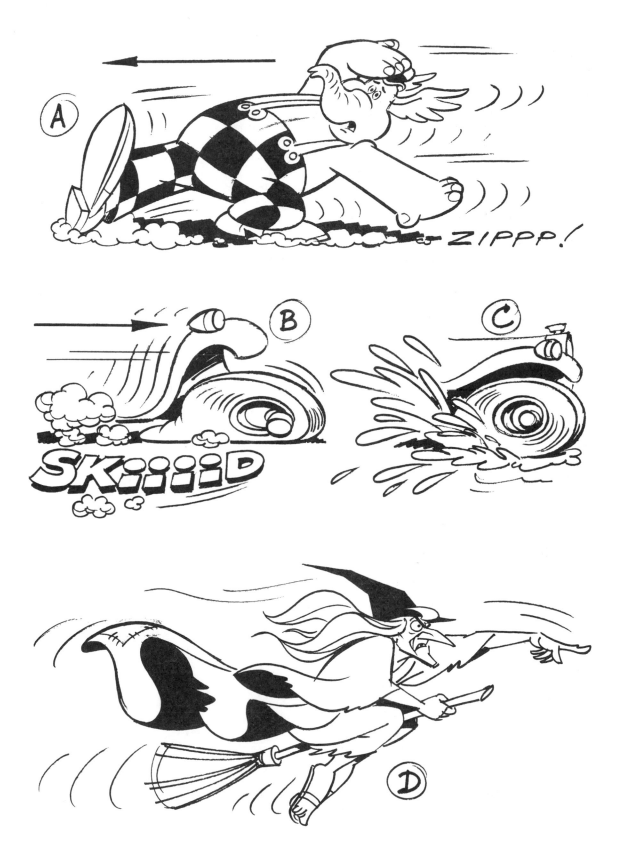

Timing cycles—how long a repeat?

A naturally repetitive movement, like that of a piston, or a run, can have quite a short cycle. A run might take 8 or 10 frames for two paces and would probably need one drawing per frame.

Other actions, such as a fire burning, which are not repetitive by nature, require extra cycles of approximately one second or more. The number of extra cycles required to add variation to the movement depends upon the number of times it is to be repeated.

Smoke is another example which would need a repeat of a second or more. This can be arranged so that the repeats on the drawings become closer and closer together at the top, so that the speed diminishes as the smoke breaks up and disappears.

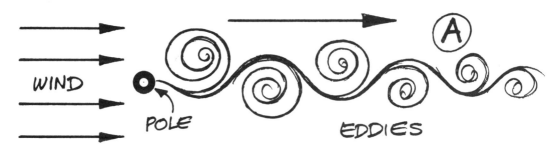

A Plan view of eddies formed as wind passes pole. Each eddy is a cylinder roughly at right angles to the paper.

B Wave shape of flag between left and right eddies.

C Repeating animation cycle. The wave crest marked X follows itself along the flag ad infinitum.

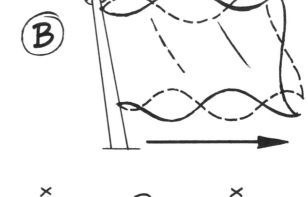

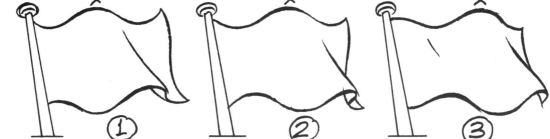

If a snow cycle is either to be run for a long time or to be used in several scenes, it needs a cycle of several seconds so that the repeats are not apparent. If it is animated on several levels (foreground, middle distance and distant) and the three cycles are made of different lengths, they repeat differently each time round and give the effect of a very long cycle.

A waving flag

The movement of a flag in the wind is an example of a wave movement which is used very often in animation.

Seen in a simplified form (Fig. A), a steady wind is split into eddies on alternate sides of the flagpole, looking much like the wake of a ship in water. Each of these eddies is roughly a cylinder, more or less at rightangles to the paper. A flag attached to the pole is blown to the right and assumes a wave shape, sandwiched between the alternate eddies (Fig. B). The cloth of the flag makes the movement of the wind visible. As the eddies follow one another to the right, so the waves in the cloth follow one another along the flag.

Fig. C shows a simplified repeat cycle of this. The wave crest marked X travels along the top of the flag to the right followed by a trough caused by the alternate eddy. This is followed by another crest similar to X which can be animated into X again to complete the cycle.

Note that in this kind of movement there is no actual 'key' drawing. All the drawings are of equal importance in the series and each one must flow smoothly to the next.

Depending on the length of the scene it is advisable to draw one or two variations which can be introduced to give more interest to the repeat.

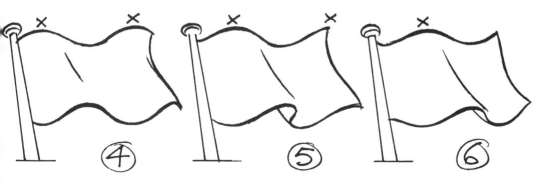

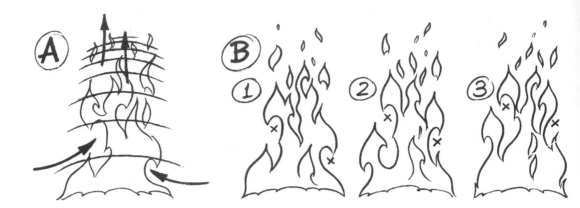

A Cold air is drawn in at the base of a fire and rises as it is warmed.

B A fire cycle, 1–8. The eddies marked X follow one another upwards, slowing down as they rise.

Effects animation: flames and smoke

The movements of flames are governed by the movements of air currents above the fire. The hottest part of a fire is in the centre and above this the hot air rises. As it rises it is replaced by colder air rushing inwards from the sides. This air in its turn is heated and rises and so the process is continuous. This flow of air usually gives a roughly conical shape to the flames, with a succession of indentations representing eddies of cold air, starting at the base of the fire and moving inwards and upwards.

The timing of these movements is fastest at the base where the fire is hottest, slowing down on the way up. As the individual flames taper off, break up into smaller pieces and disappear, so the speed should diminish also. The shapes must be kept fluid and ever-changing, although they should still be identifiable as smoothly rising areas of flame. If areas of flame stick in one place or even appear to animate downwards, this ruins the effect.

The timing of the flames also depends on the size of the fire. A big fire is hotter than a small one and, therefore, much bigger volumes of air are involved. Obviously, in a big fire an individual flame takes longer to work its way from the base of the fire to the top, probably several seconds, whilst in a small fire it might only take a few frames.

Flames are volumes of gas which can ignite or die out quite suddenly and can therefore change their volume quickly from one drawing to the next—against the normal rule in animation that volumes should stay the same. Surges of flame usually appear quickly and die away more slowly.

Smoke can be treated in many ways but the main timing problem is how to plan a repeat which does not appear too mechanical.

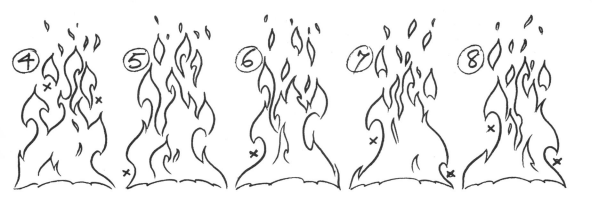

One way of doing this is illustrated on page 85. A variation on this basic idea is to animate puffs arranged on a wave pattern. These may remain as individual puffs or merge into one another to form an irregular column. A cycle of this type of smoke would take 32 frames or more.

A succession of quick puffs, as from a car exhaust, if repeated, may need two or more different shapes of puff, or perhaps alternating puffs and smoke rings, as the same puff repeated looks mcchanical.

A really big column of smoke rising from a fire forms a mushroom or smoke ring—a doughnut-shaped eddy with a hole in the middle.

C and **D** Alternative smoke cycles. Points Y animate upwards to Y, and points Z to Z.

E Car exhaust cycle.

F Billowing smoke, showing introduction of new arcs.

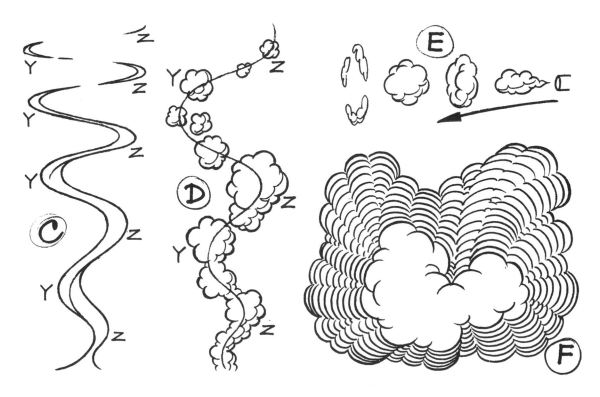

Water

Water moves in a very characteristic way as it has no mechanical strength and is held together only weakly.

In a water splash, each little drop making up the mass of water at the start proceeds on its own trajectory, or parabola, regardless of what happens to any other part of the splash. In a splash, the water radiates from a central point. It starts as a mass of water which spreads out into irregular sheets, held loosely together by surface tension. As it spreads out even further, the surface tension breaks down and the sheets disintegrate quite suddenly into drops which continue outwards individually.

Each part of the water in a splash proceeds on its own parabola, regardless of what happens to the rest of the splash. As the water radiates outwards it spreads into sheets, as in 7 and 8; then splits up into individual drops, as in 9. It is not necessary to animate out every drop individually—they can be left off a few at a time, provided the downward movement is maintained.

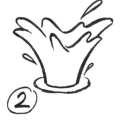

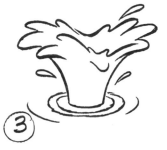

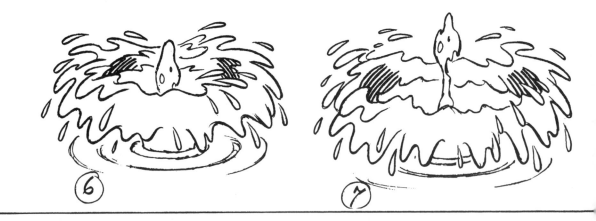

Take, for example, a heavy stone dropped into a lake. As the stone enters some water is dispersed by it and this radiates upwards and outwards to form the splash. As the stone goes deeper it momentarily leaves a space behind it. This is rapidly filled by water coming in from all sides and as it meets in the middle the force causes a jet of water to erupt vertically in the middle of the splash. This usually splits into drops before falling back. So a splash of this kind must be timed as two separate events.

A large body falling into a tub would give a rather different effect. There is only a limited amount of water, and the body would force most of it out between itself and the sides of the tub. This would be similar to the first splash above, but there would be no secondary vertical jet.

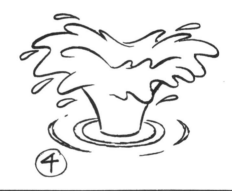
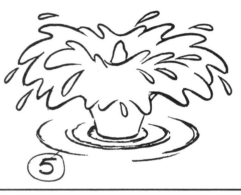

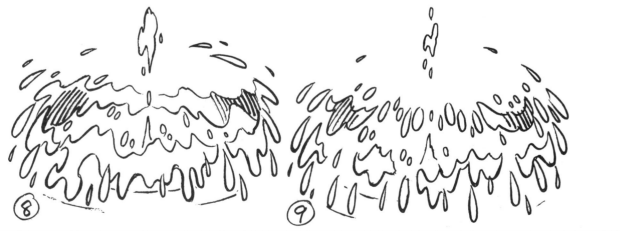

Water under pressure can exert a considerable force. If a jet is directed upwards at an angle it describes a parabola as each individual drop behaves like a ball thrown through the air (see page 35). If a jet of water hits a flat surface, the water is reflected back like light in a mirror, although with a good deal of random movement as well.

Water thrown from a bucket behaves like a splash. The water leaves the bucket as an irregularly shaped lump which becomes streamlined in the direction of movement. Then individual parts of the water travel on their own parabolas, which diverge so that the water is stretched and then breaks into drops as before.

Drops can be made to animate smoothly by streamlining them into long narrow shapes and moving them along parabolas with a slight overlap in length between one drawing and the next. It is not necessary to follow each drop to its logical conclusion by animating it off screen or hitting the ground and splitting into smaller drops again. It is usually enough to slow down and diminish the sizes of the drops around the edge of a splash, eventually losing them

A Each drop of water in a hosepipe jet travels on its own parabola. Partial gaps in the jet help to avoid strobing in animation.

B Semi-diagrammatic illustration of a jet from a moving nozzle.

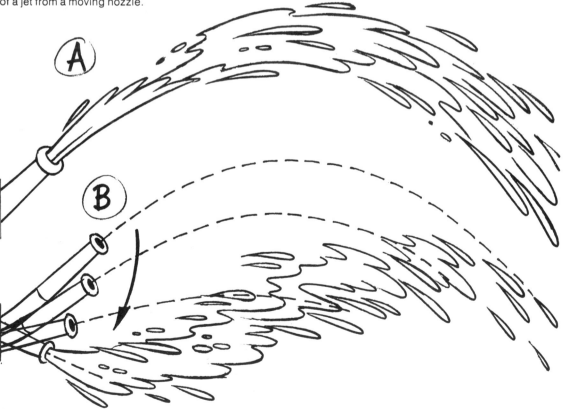

altogether. This is effective as long as a lot of drops do not disappear on the same drawing but are allowed to vanish in a random way over a number of frames.

Effects around objects partially immersed in water are usually shown as ripples, which radiate from around the object and gradually split up and disappear. If the object is not moving or if it is moving in a cyclical way, then the effects can be made into a cycle. But if the object itself is animating, the effects must be animated continuously, which can mean a great deal of work.

A lot of work is involved in animating the disappearance of water spilt on the ground. This movement requires several seconds and is generally done by producing a series of holes in the water, increasing them in size until they coalesce and finally the water disappears. As far as possible such a situation should be avoided.

To achieve realistic liquidity, the timing for animation of water is quite critical. If timed too slowly it looks oily or even treacley, whilst if timed too quickly it may fizz in an unliquid way.

C Ripples from a partially submerged object are usually animated as concentric ellipses moving outwards and gradually disappearing.

D Part of a cycle of the reflection of a bright light in almost still water.

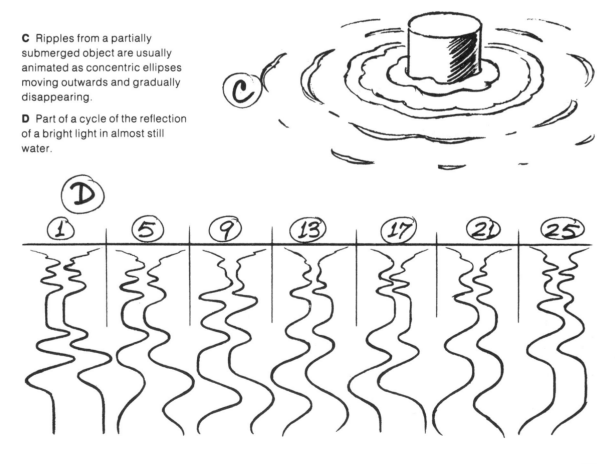

Rain

One problem with animating rain is that it can appear very mechanical. Although rain actually falls in more or less parallel lines, it must be animated with a more random slope if a realistic effect is to be achieved. It is best to time it moving quickly down. If it is drawn on more than one level, the distant rain should move more slowly, to give depth. Foreground rain should cross the screen in about six frames whilst more distant rain should move progressively slower.

Individual drops are drawn as straight lines with consecutive drawings overlapping each other slightly. Rain almost certainly needs single frame animation for a realistic effect. It also needs a fairly long repeat if it is not to appear too mechanical—24 frames at least.

For really heavy rain, the effect is enhanced by animating a cycle of drops hitting the ground. These can be quite random and unrelated to the falling rain. Each drop should animate out in about six frames. Live action rain has often been used in animated films, shot against a black background and double exposed over the cartoon.

As with all effects animation, rain can express a mood by its timing. For a miserable mood, rain can fall vertically at perhaps half its normal speed, whilst the speed can increase with a greater tilt from the horizontal for more violent moods.

A really stormy effect would need to show random gusts of wind and would be very difficult and time-consuming to animate. This is one reason for the use of live action.

Water drops
When shaking water drops from a brush, for example, the drops should start one drawing later than the extreme of the brush, travelling in a continuation of the direction of the brush before the flick. In other words, before the flick the brush and water are travelling together, after the flick the brush changes direction, but the water keeps going.

Snow

Gently falling snow drifts in wavy lines and needs even longer cycles than rain to avoid the audience noticing the same flake following itself down the same track. Two seconds may be too short if the repeat is run more than a few times. A foreground flake may take about two seconds to cross the screen, but of course may take less.

To give depth to the snowfall, at least three different sizes of flake are usually needed; the smaller more distant ones travelling more slowly than those in the foreground. Distant snow is not generally animated out of the bottom of the screen but fizzles out in a random way somewhere on the screen. The exact point where it disappears depends on the background on which it is used.

A Tracks for foreground rain cycle.

B Tracks for more distant rain.

C Cycle of raindrops hitting the ground.

D Shaking a wet brush. 1 and 2, the brush moves to the right. 3 and 4, brush moves to the left, water continues to the right.

E Tracks for a foreground snow cycle.

F Tracks for a middle distance snow cycle. A distant level would be needed below this on long shots etc.

Snow is usually produced by the animator providing a drawing of the wavy tracks of the snow, with graduations marked on them and numbered so that the snow can be traced directly onto cel, usually with a drybrush. Blizzards present a similar problem to rainstorms, the tracks become more horizontal as the wind speed increases and a real storm effect calls for eddies and surges in the movement.

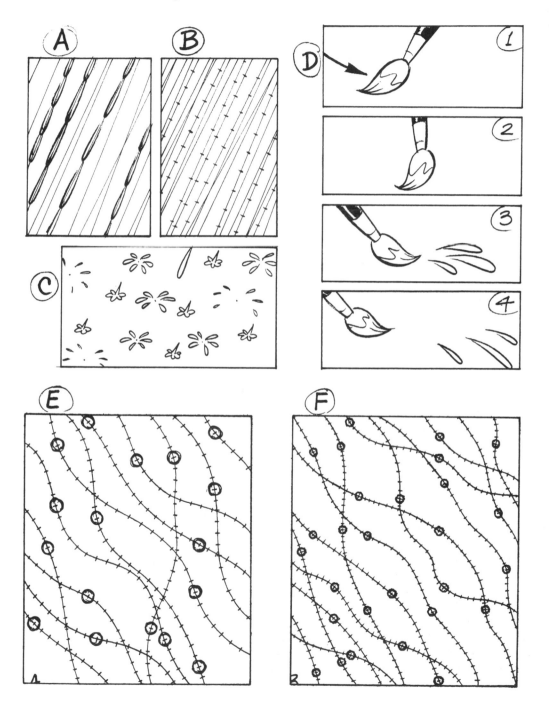

Explosions

As explosions are intended to shock the audience, it is not advisable to use a predictable formula for them. There are many different ways of making the effect of an explosion but there is some similarity in the timing in each case. There should be a quick anticipation of some sort, then a quick burst or series of bursts which should be kept going for some frames, followed by a slower dispersal.

Explosions, therefore, start with a very fast movement and taper off to a slow finish. As the initial burst is so quick, a short anticipation which attracts the eye to the point of explosion just before it happens, increases the effect. Four or five frames should be enough for this.

Once the explosion starts it should fill the screen in perhaps three frames, followed by a flicker effect for about six frames and then a slow clearance of smoke lasting several seconds.

A small bang, such as a pistol shot, can finish in perhaps five frames, but a larger explosion needs extending in time to be effective. A really impressive explosion, such as a long shot of a building blowing up, probably needs the burst itself to last for a second or more, perhaps by arranging a succession of secondary explosions within the main one. This also would require a slow aftermath with perhaps a column of smoke rising, and so on.

Smaller effects, which work on similar lines to explosions, are called 'splats'. These animate out in about five frames from the point of contact of a blow to emphasise the impact. They are usually painted white. To emphasise a lesser impact, one can animate out short radiating lines for about the same number of frames. Door slams can be emphasised either with a splat or with a number of radiating puffs of dust from the edges of the door. These also should disappear in about five frames.

A 1–14, a possible explosion. Drawing 2 is a quick anticipation followed by multiple bursts which could be alternated with black-and-white frames. After drawing 14 the dust would slowly disperse.

B A specimen 'splat'.

C Dust, stars, radiating lines etc, can be used to emphasise an impact.

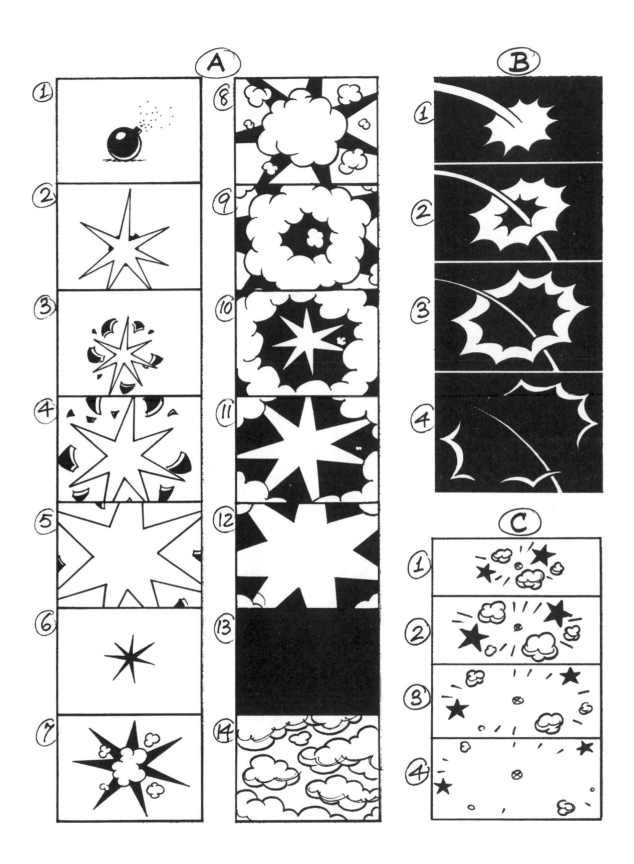

93

Repeat movements of inanimate objects

In straightforward to-and-fro movements, such as those of a piston or pendulum, it may or may not be possible to use the same drawings in the reverse order for the return movement. With a rigid pendulum (Fig. A) it would be possible, but with a cartoon piston (Fig. D) animated with steam pressure in mind, the drawings used for the forward movement would not work in reverse.

In any flexible movement, or that of any object which has something trailing, then a fresh set of inbetweens must be done for the two directions of movement (Figs B, C and E).

In a to-and-fro movement in which the same drawings can be used in reverse, an optical problem arises at the ends of the movements. Suppose the animation is done on double frames and charted: 1, 2, 3, 4, 5, 6, 5, 4, 3, 2, 1, 2, 3... etc. it will be seen that drawings 5 and 2 occur twice, that is, they are on the screen for four frames out of six and so make a greater impact on the eye than the actual extremes, which in this case are 1 and 6. This effect can be avoided either by holding drawings 1 and 6 for four frames each, or else by missing out one of the exposures on 5 and 2 thus: 1, 2, 3, 4, 6, 5, 4, 3, 1, 2, 3... etc.

A similar optical effect can occur with eye blinks if the same inbetweens are used on the way down as on the way up, especially in close ups. In this case it is better to space the two sets of inbetweens differently so that the same positions do not occur on both the opening and shutting movements.

A A straightforward swing cycle, in which the same drawings can be used for both directions of swing.

B Flexible objects tend to swing more like this.

C, **D** and **E** Short repeat cycles in which the same inbetweens cannot be used in both directions of movement.

F An eye blink.

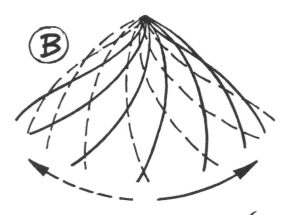

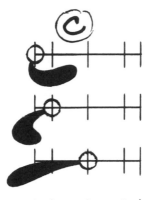

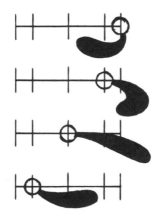

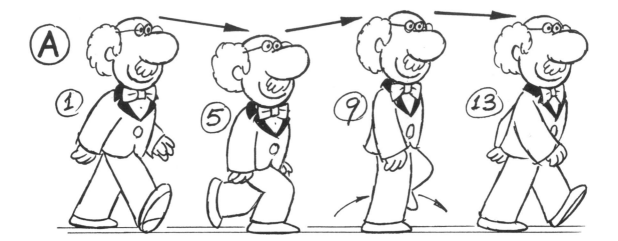

A Part of a walk cycle, spread out for clarity. The complete cycle would be 1–23 (ie 1 = 25), 17 being the same as 5 with legs reversed, and 21 the same as 9.

Timing a walk

What are the main features of a 'normal' human walk?

Walking has been described as 'controlled falling'—a skilled manipulation of balance and weight.

The only point in a walk when the figure is in balance is at the instant when the heel of the front foot touches the ground; the body weight here is evenly spaced between the two feet. This is usually the main key drawing (Fig. A). It gives the stride length, and so can be used for planning the number of steps needed for the character to cover a certain distance. This 'step' position is the one with the maximum forward and backward swing of the arms. It is actually the middle of the fall forward onto the front foot, when the front knee bends to cushion the downward movement of the weight. The key position here is usually known as the 'squash' position (Fig. A5). The body's centre of gravity is at its lowest point, and the body weight is supported by the front leg. The back foot is almost vertical, and although the toe is just touching the ground, it bears no weight at all in this position. In Fig. A9 the bent leg straightens, lifting the centre of gravity to its highest point as the back foot moves forward. This is the 'up' position and leads into the next 'step' at 13.

There are two slightly different ways of animating a walk—the choice is one of convenience. Suppose a character makes a 1.8in stride in 12 frames. Assuming that the walk is a repeat movement, then if we call the left 'step' drawing 1, this drawing will appear again 24 frames later (ie drawing 25 = drawing 1) 3.6in left or right of the original position (Fig. B). So the intermediate positions of the walk can be animated between these two positions. The character can then advance along the cels, relative to the pegs, until it arrives back at drawing 1 at which point the pegs are moved 3.6in and carry on for the next two steps.

D Successive positions in a naturalistic walk. The left shoe is shaded black. Note that on 11 the left leg is straight just before making contact with the ground on 13 (see next page).

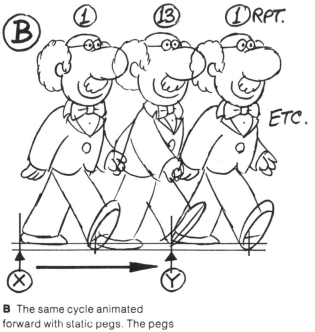

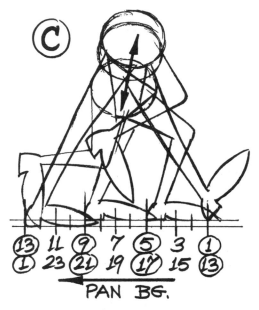

B The same cycle animated forward with static pegs. The pegs stay in position X whilst the figure moves forward on 1–23. The pegs then move to the right by the length of two strides and 1–23 is repeated in the new position Y.

The alternative method (Fig. C) is to animate from drawing 1 back to drawing 1 in the same position, so that all the bodies in the cycle are superimposed over one another, with an up-and-down movement only, instead of advancing along the cels. The 3.6in which the figure moves along every two paces is now taken up by moving the foot backwards 0.15in per frame. After 24 frames the feet have effectively slid back the 3.6in to make up the two steps. This is called 'animating on the spot' because to make a man walk by this method the pegs carrying the figure remain static while the background pans backwards by the same amount as the feet per frame.

C A walk cycle 'on the spot'. The body moves up and down whilst the heels slide backwards along the scales at the same speed as the background pan.

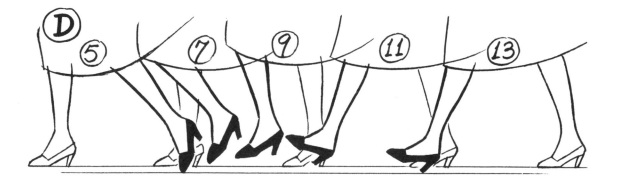

97

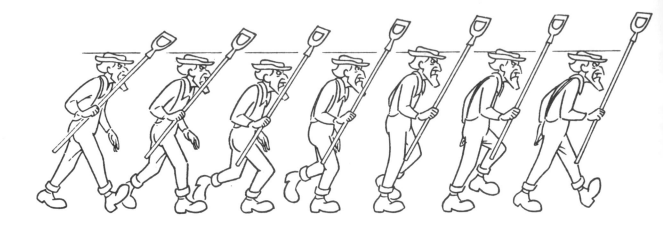

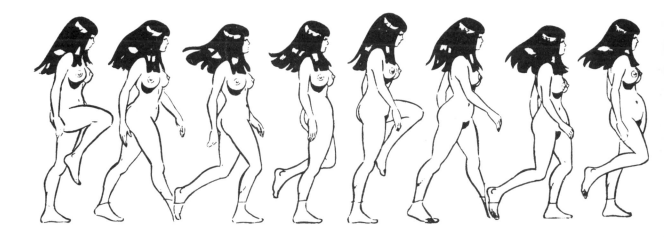

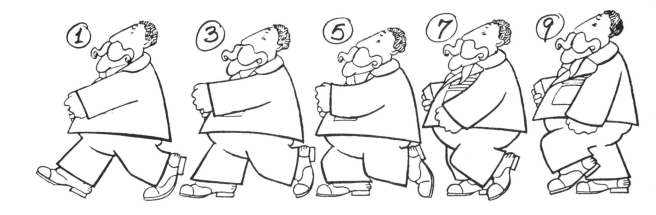

Types of walk

The up-and-down movement of the body should slow in and out of the key positions, but the forward movement of the body should be at a uniform speed, or the animation 'sticks'.

It is important that there is just enough time for the straight leg to register on the screen in the 'step' position. As the front leg is bent both before and after this position, there is a danger that the eye will connect these two positions—missing the straight leg—with the effect that the character is doing a 'bent-leg' walk. Fig. D on the previous pages gives another variation of this problem. It is based on a naturalistic walk, and the left leg kicks out straight on drawing 11, although it is still moving forward to the 'step' position 13. The front foot should slap down flat on to the ground quickly after the 'step' drawing. This loosens the ankle joint.

There are many variations on this walk. For example, in an aggressive walk the body leans forward, the chin is out, the fists are clenched. In a proud or pompous walk the body may lean slightly backward, with the chest out and plenty of shoulder action, with the highest position on the 'step' drawing. In a tired walk the body and head droop, arms may hang loosely and the feet may drag along the ground, and so on.

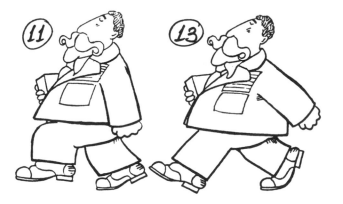

Three different styles of walk:

Top One step (12 frames) of a 24 frame cycle.

Middle Key positions from a 48 frame walk through deep snow. On double frames two inbetweens are needed between each pair of keys.

Bottom One stride of a 24 frame cycle on double frames. The two 'step' positions are drawings 1 and 13. The weight of the body squashes onto the front foot on 5 and rises as the back foot comes forward on 9. Note how the front leg remains straight on 3 to avoid the 'bent leg' look.

Spacing of drawings in perspective animation

To animate in true perspective requires complex draughtsmanship and some understanding of the geometrical treatment of the subject.

Especially when a character walks in perspective, an accurate perspective grid must be drawn giving the height of the character and the length of the strides, so that the animator has a clear idea of how the spacing of the strides gradually increases or decreases. It is quite a difficult animation problem to make all parts of a figure get larger or smaller and yet remain in the right proportions.

For dramatic effect when a character rushes towards or away from the camera, a low horizon is preferable. High horizons provide a more relaxed effect. In both instances the vanishing point must be established in relationship with the horizon, which represents the camera or the audience's eye level. The

A Side view of imaginary grid constructed around successive 'step' positions of a walk cycle.

B A similar grid to A, drawn in perspective.

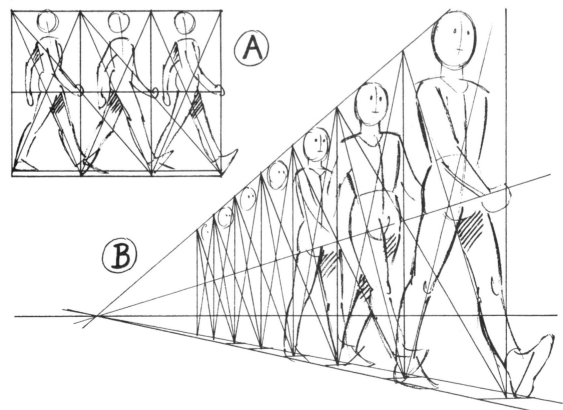

increasing or decreasing lengths of strides must be worked out by defining measuring points for every few drawings. Estimation is possible, but must be plotted out carefully.

Variation in perspective can be achieved by lowering the horizon and changing the vanishing point during animation. This, however, requires some experience. Weight must be evident in all perspective animation. In a perspective shot, a character can run from the foreground over the horizon in a few frames, approximately 12 to 16, provided the right degree of 'anticipation' is provided. Because of the speed of the action it is better to use single frame animation.

Effective animation requires movement in space and an illusion of three dimensions, otherwise the characters may appear to be too flat. Take advantage where possible of opportunities for movement in exaggerated perspective. For instance, if some part of a figure or object swings round close to the camera, emphasise the increase in size in the drawings.

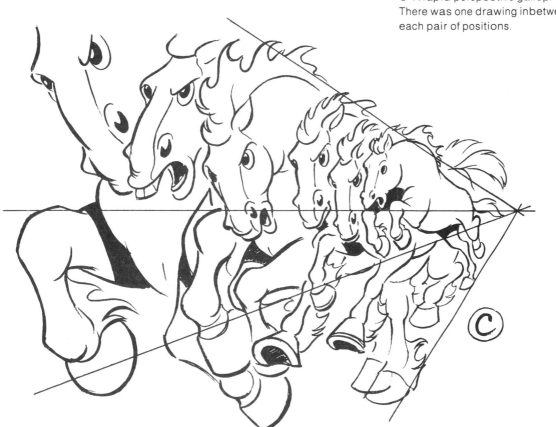

C A rapid perspective gallop. There was one drawing inbetween each pair of positions.

Timing animals' movements: horses

The order in which the feet of a horse touch the ground is: back left, front left, back right, front right, back left, front left, back right, front right etc.

A horse normally takes about a second to make one complete stride, that is from 'back left' to 'back left'. If it is walking freely the feet touch the ground at equal intervals of time.

If 24 frames is taken as the length of a walk cycle, back left hits the ground on frame 1, 'back right' hits the ground on frame 13 and 'front left' and 'front right' hit the ground on frames 7 and 19 respectively.

In the step position on the back legs, on frames 1 and 13, the back legs form two sides of a triangle. The rump is lower than it is on frames 7 and 19, where one leg is vertical as the other one passes it. The shoulders are lower on frames 7 and 19 than they are on frames 1 and 13 for the same reason. This causes a slight rocking movement to the line of the horse's back. Also on the front step positions, as the shoulders go down, the head is pulled into a slightly more horizontal slant than it is on frames 1 and 13.

In a normal walk, a horse's front legs step half a pace later than the back legs. The body and head tilt slightly as a result of the alternate stepping of the back and front legs.

On the right, a cow walking, from *Animal Farm*.

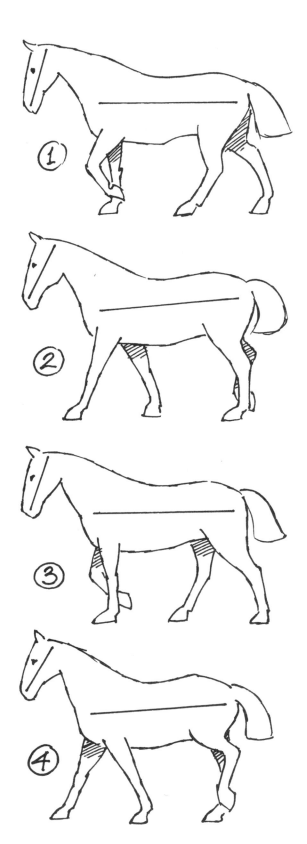

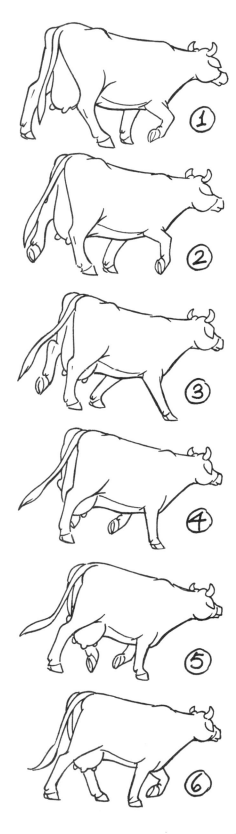

Timing animals' movements: other quadrupeds

Other quadrupeds, like cows, are surprisingly similar in the timing of their walk to a horse. The order of the feet is usually the same and the movements of the back and the head follow the same pattern.

An elephant may take a second or perhaps a second and a half to make a complete stride, whilst a smaller animal such as a cat may take a complete stride in half a second or less, although these timings may vary greatly.

Some animals, such as the deer family, lift their feet high when walking; cats also do this when stalking. There is no equivalent of the 'squash' position of a human walk in a four-footed walk, as the back foot of each pair usually comes off the ground immediately the front foot is on the ground.

A walking animal spends roughly half the time supported by two legs and the other half supported by three. A four-footed animal starting a walk usually starts with one of its back legs, followed by the front leg on the same side.

Parts of cycles of a tiger and a deer walking. In both cycles drawing 17 has the opposite feet positions to drawing 1, so the complete repeat would take 32 frames. Although the length of stride is the same in both these examples, note the difference in feeling. The tiger has a crouched, menacing attitude, whilst the exaggerated lift of the legs helps the deer's motion to be bouncy and light.

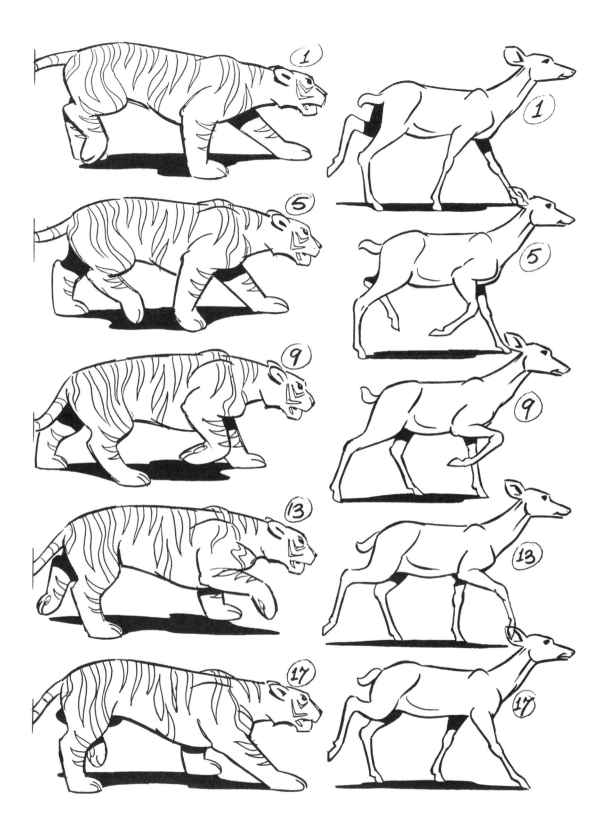

Timing an animal's gallop

A horse increases its speed from a walk, to a trot, then a canter and finally to a gallop, at which it travels at maximum speed.

In the gallop a complete stride takes about half a second, and the order in which the feet hit the ground is: back left, back right, front left, front right—pause—back left, back right, front left, front right etc. The back legs make the same movement as each other with a slight time lag and the same happens with the front feet. The big push is given by the front feet and after this push the animal becomes momentarily airborne.

In some animals, for instance the cat, the bigger push comes from the back legs and the cat becomes airborne after this

The flexibility of the pastern or wrist joint of a quadruped during a gallop is particularly noticeable. This joint can bend backwards into almost a right angle as it takes the weight of the animal (drawings 1 and 7) and can also bend into almost a right angle the other way when relaxed and the foot is in the air (drawings 2, 3, 5 etc).

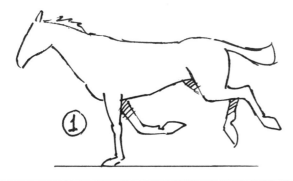

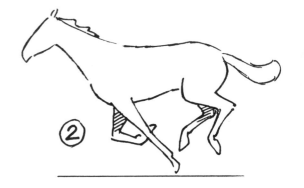

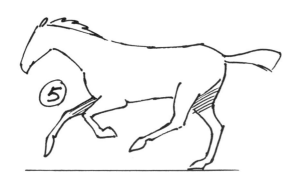

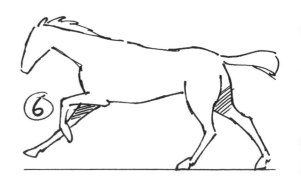

movement. The shoulders and rump rise and fall giving a rocking movement to the line of the back and the head is tilted at a slightly more horizontal angle as the shoulders go down and the front legs take the weight. The spine itself also flexes and extends. This is very noticeable with a cat; as when the back legs come forward a pronounced hump appears in the lower half of the back, and as the back legs push the body into the spring, the spine stretches out into a reverse curve. The movement of the hip joint comes strongly into play in a gallop and the forward and backward movement of the thighs, combined with the bending and stretching of the spine, gives the impression that the animal's body is alternately lengthening and shortening. When the big leap comes from the back legs, as with a cat, the order of feet hitting the ground is: back left, back right—pause—front right, front left, back left, back right etc. The complete stride of a cat takes about $\frac{1}{3}$ second.

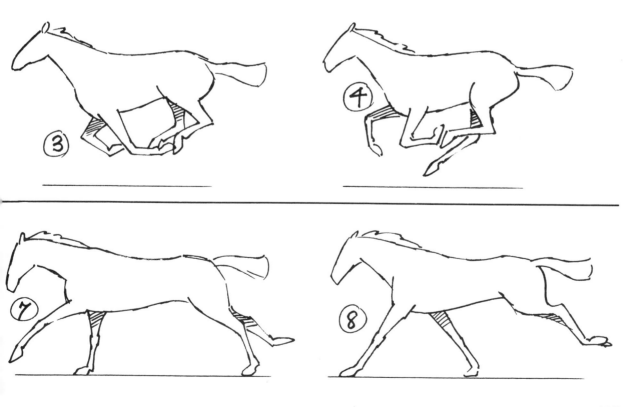

Bird flight

Birds are well adapted to fast movement through the air. They are streamlined and waste the minimum amount of energy in the air. The body enhances the movement by lying in the direction of the airflow. The legs are tucked up or trailed in flight.

The aerodynamics of bird flight is very complex and it is unnecessary to go into detail. The power stroke is the downward stroke against the cushion of air beneath the bird, and during it the air resistance closes the feathers and the wing makes as large an area as possible, to maximise the thrust. Birds have very large chest muscles to power the downstroke. The muscles controlling the upstroke are much smaller, as the air resistance is much less. During this stroke the wing folds partially to present a smaller surface area and the feathers tend to separate like vanes to allow the air to pass between them. The body is usually tilted slightly upwards at the head and is lifted slightly during the downstroke and falls again during the upstroke.

In normal flight the wing strokes are not straight up and down. The direction of beat is slightly backwards on the upstroke and slightly forwards on the downstroke. This is the opposite of what might be expected for forward flight, but the forward impetus is actually given by the tilt of the wing surfaces. This forward and backward wing beat is particularly noticeable when the bird is hovering (the body may be almost vertical and the wing beat almost horizontal) and also when the bird is rising or coming in to land.

During a flying cycle, the upstroke and the downstroke take about the same time, although with larger birds at least, the downstroke is slower. The length of the repeat depends on the size of the bird. On the whole a large bird moves more slowly than a small one. For example, a sparrow may make twelve complete wing beats in a second, whilst a heron or a stork may make only two.

A pigeon hovering as it comes in to land, from 'Animal Farm'. Note the upright position of the body and the circling movement of the wings.

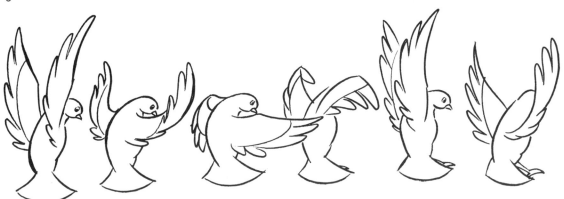

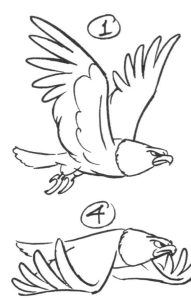
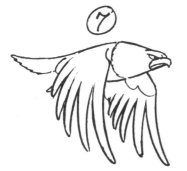
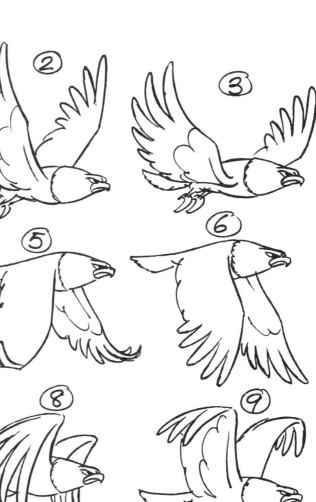

1–9 is a repeat flying cycle. The body dips slightly in the air on 1 and rises slightly on 6 as the wings press downwards. The wingtip feathers radiate from the 'wrist' and trail backwards in the direction they are coming from to give flexibility. Note how these feathers separate on the upstroke—7 and 8—to allow the air to pass between them.

Drybrush (speed lines)

Drybrush (speed lines) should be timed quickly so that by the time the audience is aware of it, it is gone. 3 frames is about the minimum effective length, but some spectacular examples can extend to 16 frames or more. The important factor to remember is that drybrush is something left behind by the object causing it. It must not move with the object as this gives the impression of threads attached to it.

If a stick swishes through the air and two consecutive drawings are widely spaced, the drybrush would consist of curves, carefully drawn in the direction of the swish and a number of lines representing several inbetween positions of the stick. These would all be put on cel in the colour of the stick. On the next few drawings, this drybrush would be

A Speed lines disappear where they are formed or move in a slightly opposite direction to that of the object causing them.

B and **C** Speed lines left by rapidly moving objects.

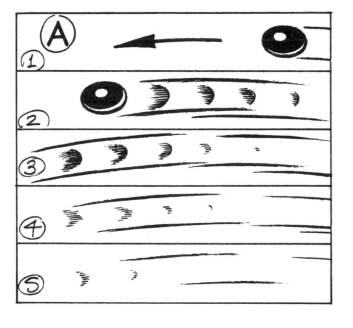

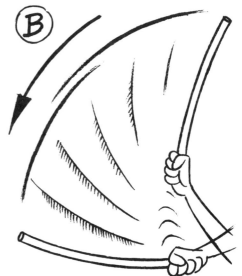

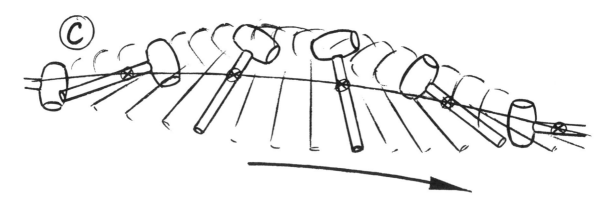

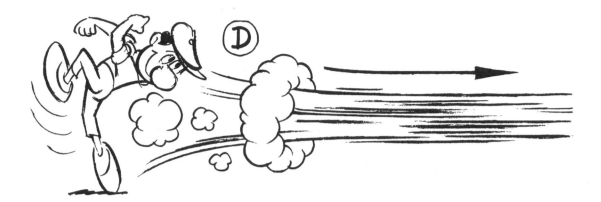

D A character zooms off screen.

animated away (ie diminished to zero) in the same place as it originated, or moving very slightly in the opposite direction to the stick. In the meantime, further drybrush may have appeared. This would be animated out in the same way.

Drybrush should be used very sparingly and should be saved for situations where drawings are so widely spaced that the eye has difficulty in connecting them up. If the spacing of drawings is well done and fast action well anticipated, the eye accepts very widely spaced drawings without trouble.

A more spectacular drybrush effect might be used when a character runs off screen. For example, if a character is about to zip off right, he anticipates to the left, accelerates to the right and goes off very fast. This may not work without drawing in some drybrush streaks as he runs off, moving them rapidly to the left and following each other in a series of eddies. This can easily be continued for 16 frames or so, but must move rather quickly.

E A more elaborate drybrush trail, taking 16 frames or more to disperse. This would also move in the opposite direction to that of the character causing it.

111

Accentuating a movement

In order to emphasise a movement, the introduction of a visual effect is sometimes advisable. Such an effect does help to draw attention to the point the animator intends to make, especially if the movement is a quick one. The effect, however, must be a visual complement to the movement and should grow out of the type of action on the screen. It should also be quick and not laboured, which could easily spoil the whole effect.

In the case of the fight sequence between the farmers and the animals in revolt in *Animal Farm* such extra effects were introduced to heighten the sequence's dramatic excitement.

The farmer's whipcrack, for example, was a sequence of eight drawings on single frames. At the accent of the movement, which was where the curvature of the whip reversed direction, a three frame, white 'crack' effect appeared (see page 113). The accent of the gunshot movement was where the gun barrel suddenly recoiled. The shot itself was made visible by a strong 'swish' effect followed by a slower puff of smoke as the gun barrel came forward again.

Since every situation is different, it is best to make any decisions about visual effects during the process of animation.

The whipcrack is all on single frames. The accent is on drawing 5, where the curvature of the whip reverses.

In the gunshot, drawings 2, 3, 4 and 5 are single frames. 6 and 7 are double frames, with perhaps two or three more inbetweens slowing into the hold on 8. The accent is on drawing 4.

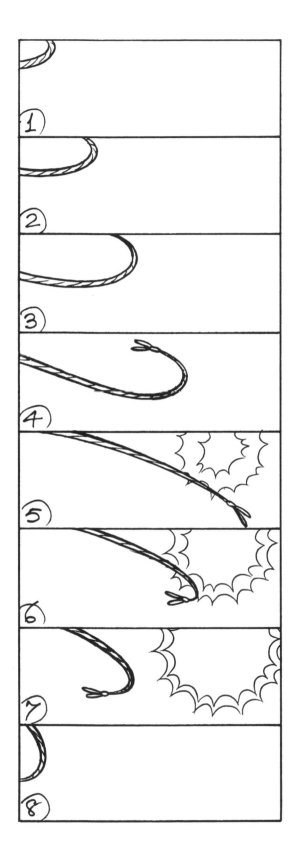

Strobing

Strobing is an effect which is an integral part of the mechanism of the cinema. Indeed the stroboscope, invented in 1832, was the first device used to present the illusion of a moving picture. The reflections of images on a spinning disc were viewed through slits around the edge of the disc so that a series of static images were seen in quick succession. A similar device, using the same principle, was the zoetrope in which paper strips were viewed through slits in a rotating cylinder.

Strobing is liable to occur in the movement of an object which has a number of equally spaced similar elements. Some examples are the rungs of a ladder or the spokes of a wheel.

If a drawing of a ladder has rungs drawn 1in apart and the ladder starts to move along its length at an increasing speed, all is well until the amount of movement on the ladder is just under $\frac{1}{2}$in. At this point the rungs begin to flicker and when the ladder moves up exactly $\frac{1}{2}$in per frame, the movement is completely confused. This is because the eye sees a set of rungs on one frame and on the next frame it sees a set of rungs half way between those on the first frame, and does not know whether the original rungs have moved to the right or to the left. On the next frame again, the rungs on the first frame have moved along 1in and so are superimposed over the rungs on the first frame. This gives the impression that the rungs are flickering on and off on alternate frames. If the movement is more than $\frac{1}{2}$in, say 0.7in to the right, the eye jumps across the shorter gap and the rungs appear to move 0.3in to the left. This is the reason for the well-known illusion of stage-coach wheels appearing to turn backwards.

The best cure for this strobing effect is to avoid situations where it may occur. The spokes of a wheel should be as widely spaced as possible. One time-honoured solution is to have one broken spoke so that the gap can be seen rotating. Another way of overcoming this problem is to show the rim of the wheel rotating, but depict the spokes themselves as whizzing round with a drybrush effect.

A wheel, or ladder, always animates comfortably in the direction required if it moves by up to $\frac{1}{3}$ of the distance between one spoke, or rung, and the next. At faster speeds, if the broken rung dodge does not work, either avoid the sequence altogether, or work on it with drybrush to suggest the speed at which it is going.

Strobing can also occur on background pans (see opposite).

A This wheel cannot rotate in less than 20–24 frames.

B This one can.

C So can this.

D This ladder is moving to the right, but the rungs will move to the left.

E Beware of equally spaced vertical lines on panning backgrounds.

F Two examples of stroboscope discs.

G A zoetrope strip.

Fast run cycles

An eight frame run cycle—that is four frames to each step—gives a fast and vigorous dash. At this speed the successive leg positions are quite widely separated and may need drybrush or speed lines to make the movement flow. Drawing 5 shows the same position as drawing 1 but with opposite arms and feet. Similarly drawings 6 and 2, 7 and 3, and 8 and 4 show the same positions. These alternate positions should be varied slightly in each case, to avoid the rather mechanical effect of the same positions occurring every four frames.

A twelve frame cycle gives a less frantic run, but if the cycle is more than sixteen frames the movement tends to lose its dash and appear too leisurely.

The body normally leans forward in the direction of movement, although for comic effect a backward lean can sometimes work. If a faster run than an eight frame repeat is needed, then perhaps several foot positions can be given on each drawing, to fill up the gaps in the movement, or possibly the legs can become a complete blur treated entirely in drybrush.

In the first example, drawing 4 is equivalent to the 'step' position in a walk, with the maximum forward and backward leg and arm movement. In a run it is also the point at which the centre of gravity of the body is farthest from the ground, that is, in mid-stride. In drawing 1 the weight is returning to its lowest point, which is in drawing 2. In drawing 3 the body starts to rise again as the thrust of the back foot gives the forward impetus for the next stride.

These are both examples of eight frame run cycles. This means four drawings to each step. Drawings 1 and 5 show the same leg and arm positions but with opposite feet, and so do 2 and 6, 3 and 7, 4 and 8. In such a short cycle these positions should be varied slightly to avoid a mechanical effect.

Characterisation (acting)

Character animation is the ultimate achievement of animation art. It is a complex combination of craftsmanship, acting and timing.

Characterisation in animation is concerned not so much with *what* the characters do, as *how* they do it. The audience is conditioned to look at human characters in human situations. In animation this can only be a starting point. The cartoon character should not behave exactly like a human being. It would feel and look wrong. Human reactions and human actions must be exaggerated, sometimes simplified, and distorted in order to achieve a dramatic or comic effect in cartoon.

For these reasons the features of characters must be kept simple, allowing for maximum facial expression. The key positions should be sufficiently expressive, and held for a long enough period of time, to transmit the message to the audience. In animation such transmission is easier in movement than in live action. When a movement is overexaggerated it tends to create a sense of comedy. This is especially the case in fast movement. A deliberate exaggeration of speed, therefore, is the basis of timing for caricature as, for instance, in the case of *Tom and Jerry* cartoons. Slower pacing requires greater emphasis on expression and characterisation of the subject. It requires more subtle animation, and it is infinitely more difficult to handle.

Facial expression is an important part of characterisation, but use the whole body to express feelings and emotions. The drawing of a character can be adapted to meet the needs of mood—in benevolent moments he would be drawn in soft, curved lines; when more aggressive the drawing would become rather angular with more straight lines; when afraid he would shrink back and become more spiky, his hair standing on end, and so on.

"TINY"

"BIG"

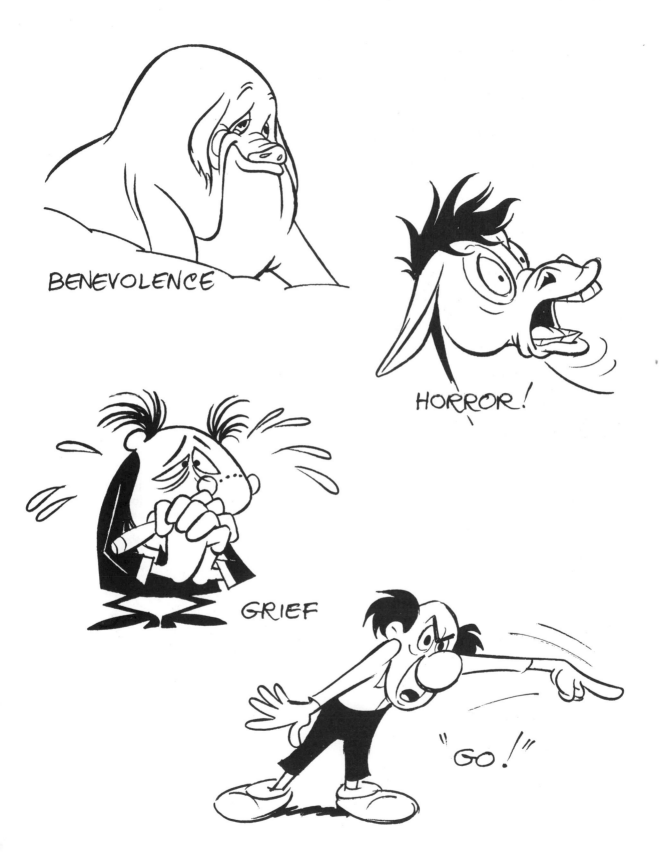

BENEVOLENCE

HORROR!

GRIEF

"GO!"

119

The use of timing to suggest mood

The creation of mood is the stock-in-trade both of the cinema and the theatre. It is also important in animated films, but as animation is a medium of exaggeration, it is advisable to avoid subtle shades of expression.

In general terms, the moods of depression, dejection, sorrow etc, depend on slow timing for their effect, whilst the moods of elation, joy, triumph and so on depend on quicker timing. Other moods, such as wonder, puzzlement and suspicion may depend on facial expression and body posture. The aim is always, however, to convey to the audience the mental state of the character, and match this to the mood of the backgrounds, the camera movements, and everything else which contributes to the visual effect on the screen.

To express depression, the character must appear to have no energy. His body droops forwards, his head hangs on his chest, his knees sag, and his movements are slow, with frequent long holds and sighs. Anything that can be used in the drawing to convey the feeling of depression should be used—the hair and clothes hang limp, perhaps the hat sinks down over the ears, and the shoes squash with the extra weight of gloom.

Elation and joy, on the other hand, need plenty of energy, which gives quick, bouncy movements with the character frequently airborne. The body is upright or curving backwards, with hair and clothing springy, and a general lightness of step.

Suspicion requires a deliberate expression of puzzlement and cannot be hurriedly timed. Give enough time for the audience to read the facial expression of the character and animate his hands for further emphasis if there is time.

Two extremes of mood. On the left, animated on double frames, abject misery because the character has been rejected. On the right, general mayhem caused by the character being given a live electric plug to hold.

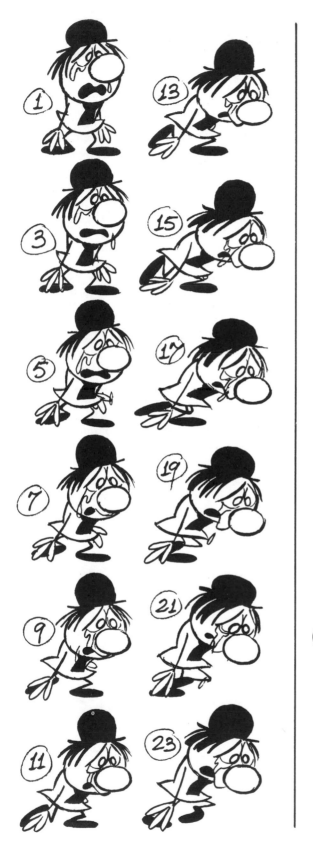
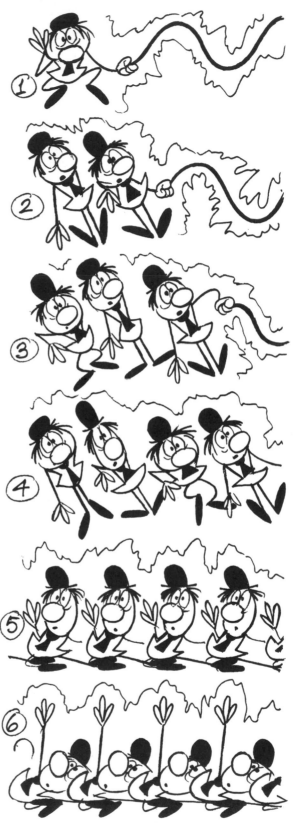

Synchronising animation to speech

Unlike live action films, where the dialogue is simultaneously recorded with the action, in animation it must be recorded beforehand so that the movement can be fitted to it precisely. It is an essential preproduction operation which cannot be left until after the completion of animation.

Once the soundtrack is available (either on tape or optical film), the type and character of the voice can be analysed through the use a of synchroniser (16 mm or 35 mm) and a frame by frame timing guide for the animation can be made. This can be done either on the exposure chart, where there is a special column for it, or on a separate chart. In either case, it must be done in terms of frame analysis. No two dialogue performances are the same. Even single words like 'you', 'yes', 'no', 'its', 'had' can vary substantially when analysed in terms of separate frames. Such information is the basis of fitting animation to sound.

Firstly, listen carefully to the soundtrack and in particular to the feeling behind the way in which the words are spoken. Then listen to the phrasing and rhythm of the speech and find the positions of the main emphases and key words. Then plan the movements of the character's body, head, arms etc, to fit the words and the way in which they are being said, to reinforce the dramatic effect. Try to emphasise the main points of the speech with the whole body, if time and budget permit it. In animation, the meaning of dialogue should be somewhat overemphasised, especially in an entertainment film.

An emotional impresario speaks the line: 'They can't do this to me!'. The broken, wavy line on the phonetic breakdown strip represents the pitch and volume of the voice. The important accents in the soundtrack are on 'can't' and 'me' so the pattern of movement should emphasise the vowels in these two words.

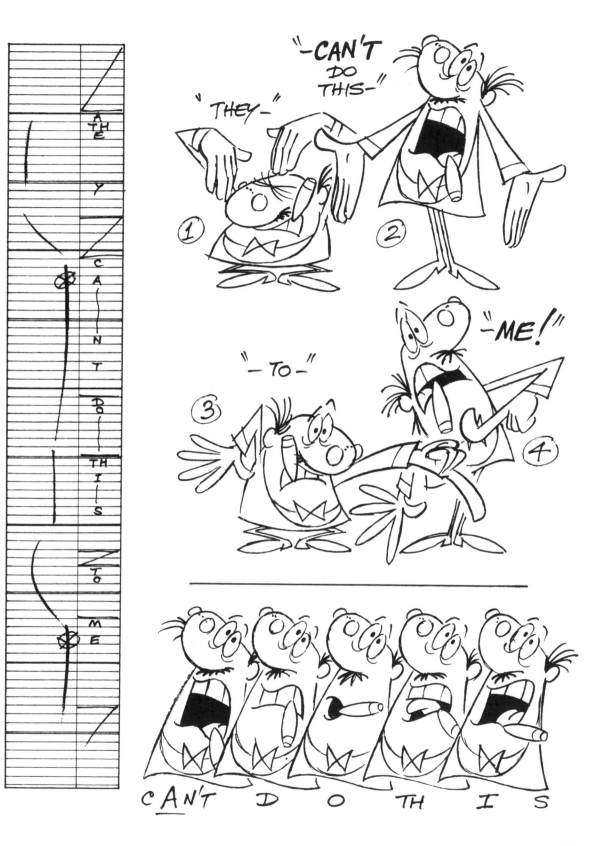

Lip-sync—1

In full animation, it is important for a character to mime. When he is speaking, therefore, his miming must be accurately synchronised to the soundtrack. Dialogue is invariably recorded before production and the timing of it is passed to the animator as a phonetic breakdown. It is also important that the animator should have a copy of the track on tape, so that he can listen to it repeatedly until the pattern of emphasis, the rise and fall of the voice, etc, is clear in his mind. It is sometimes useful to indicate this alongside the phonetic breakdown by means of a line which moves left and right as the voice falls and rises and becomes thicker and thinner according to the degree of emphasis. Usually the voice rises on important syllables or words and falls on less important ones.

A sequence of drawings in which the whole body is involved in lip-sync. After a preliminary loss of temper and intake of breath, the sergeant-major shouts: 'That man there!'.

From *The Guardsman* a Halas and Batchelor commercial for TV.

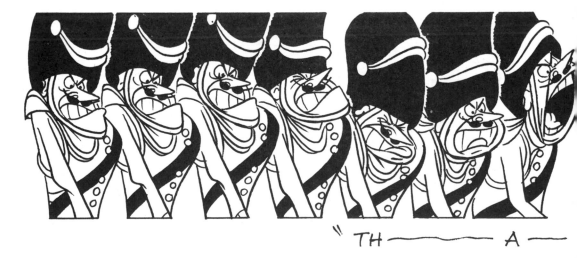

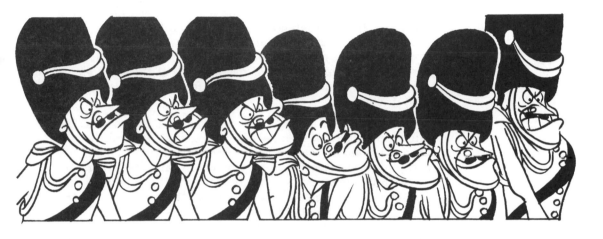

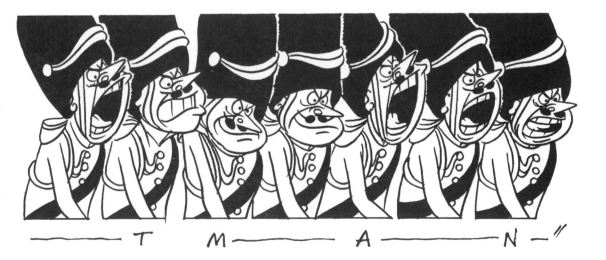

—— T M ——— A ———— N —"

Lip-sync—2

The first step is to make the character's actions fit his words. If he is aggressive he will tend to thrust himself forward and reinforce certain points with gestures. If he is shy he may shrink away and speak apologetically and if he is crafty he may pretend to smile, whilst giving quick glances to see the reaction to his words, and so on.

The second step consists of moving the character's lips and perhaps the lower part of the face, to fit the frame by frame phonetic breakdown of the speech on the exposure chart. Here it is important to listen repeatedly to the way the dialogue is spoken. There is a broad tendency for the mouth and lower jaw to open on a vowel sound and close on a consonant. In a normally spoken sentence there are usually a few accentuated vowel sounds, and the rest of the words are of lesser importance. Play the soundtrack over and over again until the pattern of emphasis, the rise and fall of the voice etc, is clear. Then plan the lip-sync to conform to this pattern in visual terms.

As already mentioned, in mass-produced TV series the dialogue carries the central interest of the film and there is practically no animation, apart from the mouth. This is not acceptable in other types of production, and it is therefore important to ensure first of all that the mouth, eyes and other features of the face should express the meaning of the dialogue. The hands should also be used for emphasis. Thirdly, the body itself should be used to underline the content. The three elements have, of course, to be closely co-ordinated.

The important elements of emphasis: mouth and eyes should express the meaning of the dialogue; hands and the movement of the body can also contribute in conveying the meaning of the dialogue.

M.P.B.

E.

A.I. (STRETCH)

D.N.S.CH.(V.F.)

BIG
 O (STRETCH)

SMALL
 O. W

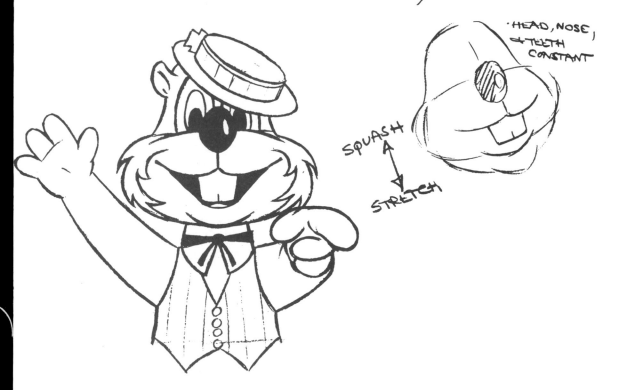

SQUASH
STRETCH

·HEAD, NOSE,
& TEETH
CONSTANT

Lip-sync—3

Once the basic timing of mouth movement is worked out, the next stage is to consider how the facial expression, head movement and body gestures can underline and add to the meaning and interest of the dialogue.

In the first speech of Old Major in *Animal Farm*, it was especially important to convey the message of this character to the audience, since the whole film was motivated by it. The facial expression had to express not only the figure's sincere concern but, as an ailing character, physical pain as well. The entire body of the pig was unanimated while it's face, eyes, mouth, snout and the facial creases conveyed the emotions of the character.

It is not essential to animate all vowels and consonants in terms of single frames. Especially in a TV entertainment series, where speed of production is essential, about eight positions of mouth and tongue are adequate.

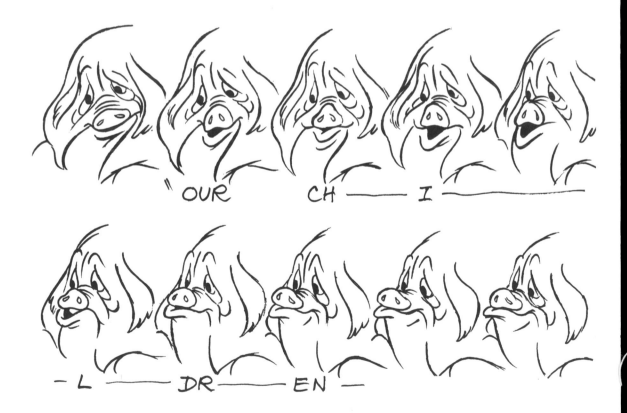

OUR CH — I

— L — DR — EN —

`M,B,P` – `A,E` – `O,AW` – `OO` – `EE` – `F` – `D,N,G,K,L,R` – `S,T`

Top Eight mouth positions which, with a few inbetweens, would cover most lip-sync possibilities in limited animation.

Bottom Lip-sync with full animation. The pig says: 'Our children are born...'

– ARE B — OR — N –"

Timing and music

Ever since the very first animated productions, Disney's *Steamboat Mickey* and Fischinger's abstract film *Brahm's Hungarian Dances*, it was clear that there is a strong relationship between animation and music. This relationship can be explained on two accounts. First, both elements have a basic mathematical foundation and move forward at a determined speed. Second, since animation is created manually frame by frame, it can be fitted to music in a very exact manner. It is further able to capture its rhythm, its mood and hit the beat right to the frame. Most animation makes good use of this advantage.

In general principle it is more difficult to follow the rhythm of a musical composition with its mood than its beat. The latter aspect of the music is easily measured, since beats are fitted into bar units of defined time length and are interpreted in time units.

Bars can contain various numbers of beats and these must be measured to the film frame. Having done this, it is comparatively easy to fit the animation to the speed of the beat and find the right type of movement to follow the music, whether it is a slow waltz of 36 frames, or 4 frames for rock music. A beat can be emphasised by synchronisation of the feet but it works better if the whole body is used. In quick beats of 3, 4 or 6 frames it is possible to follow every second beat without losing the rhythm. It is always better to work to specially prepared music if this can be afforded.

A This eight frame cycle, animated on double frames, of a whirling Spanish dancer is fitted closely to strong flamenco music. The figure fully conveys the character of the music with all its functional simplicity.

B Single and double frame animation are alternated to fit the beats of the sound of a Spanish guitar. It is essential for the movement to follow the musical lead of a specially prerecorded music track, for accurate synchronisation.

Camera movements

Tracks are used to move into a closer field or pull back to a more distant one. They are done by moving the camera frame by frame, up or down its vertical pillar, above the animation drawings. Usually the field centre also moves during a track and as the camera travels on a fixed axis this movement in a north south, east west direction is done by moving the table.

Tracks and table moves are worked out in terms of general timing—track lengths and the action which the various fields must include—by the director on bar sheets before production begins (see page 10).

When the animator finalises the action of the scene in detail, he converts the director's timing into specific instructions to the cameraman. He writes down the field sizes and marks the frames where camera movements start and stop in the 'camera instructions' column on the exposure chart (Fig. A). He also provides a drawn field key with field centres marked (Fig. B).

It then becomes the cameraman's responsibility to achieve the required effect smoothly and accurately on the screen. Briefly, the procedure is as follows: in Fig. B the track is made from field X to field Y so the screen centre moves towards the south-east. This means that under the camera, the table must move north-west. Fig. C is an enlargement of this table move, showing how the cameraman divides the line to achieve a smooth movement from X to Y. At the same time he measures the distance the camera travels on its column during the track, and divides this in exactly the same way as Fig. C, so that camera and table top move smoothly together. Fig. D is a similar track and table move which includes a tilt. This would also be done as a table move.

Tracks and table moves are usually animated on single frames.

A The director's timing of tracks is finalised by the animator in the 'camera instructions' column on the exposure sheet.

B The accompanying field key.

C Enlargement of field centres from Fig. B, inverted for use as table move.

D Another example of a track including a table tilt.

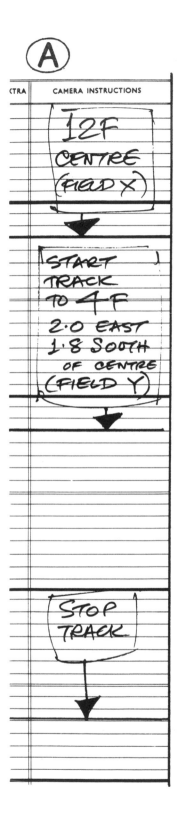

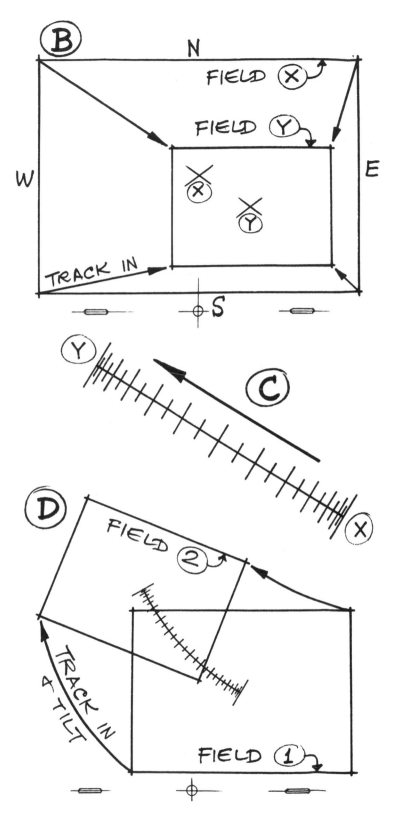

Peg movements

Peg movements, unlike those of the camera, are very closely linked to animation and therefore need to be controlled by the animator. When an object or character is moving across a background there are very often two and sometimes more sets of pegs working together, and their compensating movements need to be worked out in great detail at the same time as the drawings.

Fig. A is an example of peg instructions written out by the animator, and Figs. B, C and D illustrate the timing problems involved.

In the left hand column of Fig. A is a 24 frame walk cycle, 1L—24L. The character makes a 1.8 in stride in 12 frames on bottom pegs. This governs the speed of background pan on top pegs to 0.15 in per frame, Fig. B. The director then called for a 1 sec pan ahead to a doorway which the character is approaching on the right of the background, Fig. C. The animator therefore measures the distance ahead to the door, and by trial and error splits this up into a series of accelerating and decelerating moves to stop smoothly at the door on the required frame. The character and the background must work together so that his feet do not slip (in effect the character moves 0.15 in to the right of the background per frame, no matter what the background does). So the bottom pegs start to move to the left—always 0.15 in per frame *less* than the top pegs. At some point this will bring the character off screen, when he is replaced with a blank cel. If we imagine him continuing to walk off screen, then on an appropriate frame he starts to appear in screen again. At this point the bottom pegs are set so that his front toe is just in screen, Fig. D. The bottom pegs then pan to the right 0.15 in per frame against the static background.

The cycle 1L—24L would of course have to be on long cels with enough blank on the right of the character to pan him out of screen without the cel edge showing.

A An example of peg movements written out by the animator in accordance with the director's timing. The walk cycle 1L–24L is on the left, and in the 'camera instructions' column the bottom peg moves are on the left in decimals of an inch, and the top peg moves are on the right.

B, **C** and **D** show the positions of the top and bottom peg bars at the top, middle and bottom of Fig. A respectively.

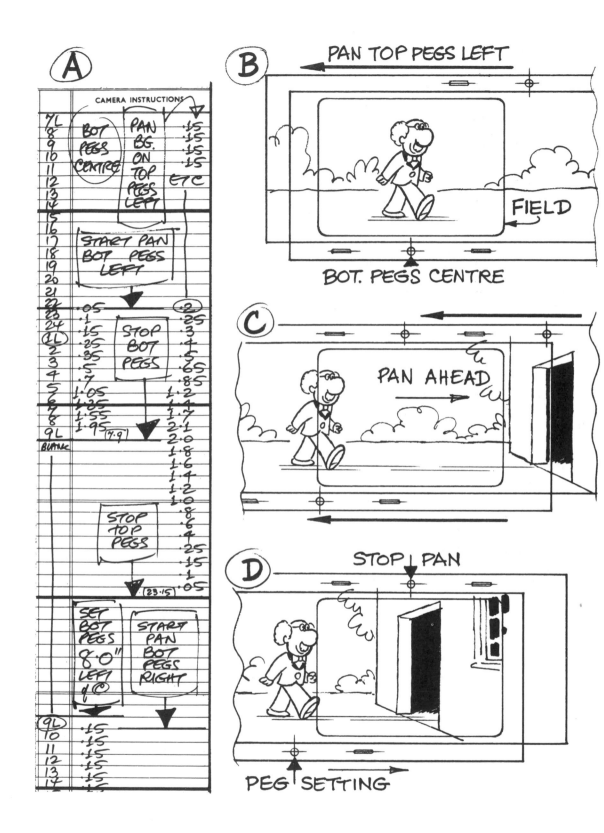

A

CAMERA INSTRUCTIONS

7L	BOT PEGS CENTRE	PAN BG. ON TOP PEGS LEFT · ETC
8		·15
9		·15
10		·15
11		·15
12		
13		
14		
15		
16		
17	START PAN BOT PEGS LEFT	
18		
19		
20		
21		
22	·05	·2
23	·1	·25
24	·15	·3
1L	·25	·4
2	·35	·5
3	·5	·65
4	·7	·85
5	1·05	1·2
6	1·35	1·4
7	1·55	1·7
8	1·95 (4·9)	2·1
9L		2·0
BLANK		1·8
		1·6
		1·4
		1·2
		1·0
	STOP TOP PEGS	·8
		·6
		·4
		·25
		·15
		·1
	(23·15)	·05

SET BOT PEGS 8·0" LEFT q ©

START PAN BOT PEGS RIGHT

9L	
10	·15
11	·15
12	·15
13	·15
14	·15

B — PAN TOP PEGS LEFT

FIELD

BOT. PEGS CENTRE

C

PAN AHEAD

D — STOP PAN

PEG SETTING

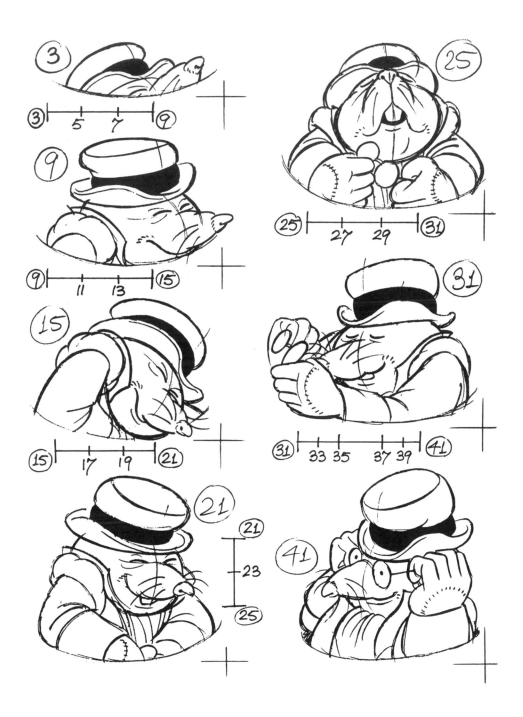

A sequence of key drawings with inbetweening scales. A mole squeezes himself up from his hole and puts on his spectacles, only to be stepped on a moment later. Note the rounded feeling of all the shapes, to give him an unaggressive, harmless look.

From *Butterfly Ball* by Halas and Batchelor.

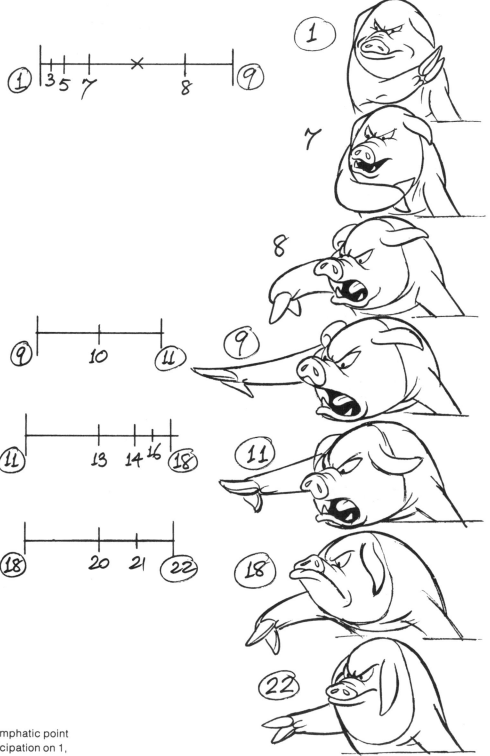

An example of an emphatic point (*see* page 47). Anticipation on 1, out to extreme on 9, back to pose on 18, and into final pose on 22.

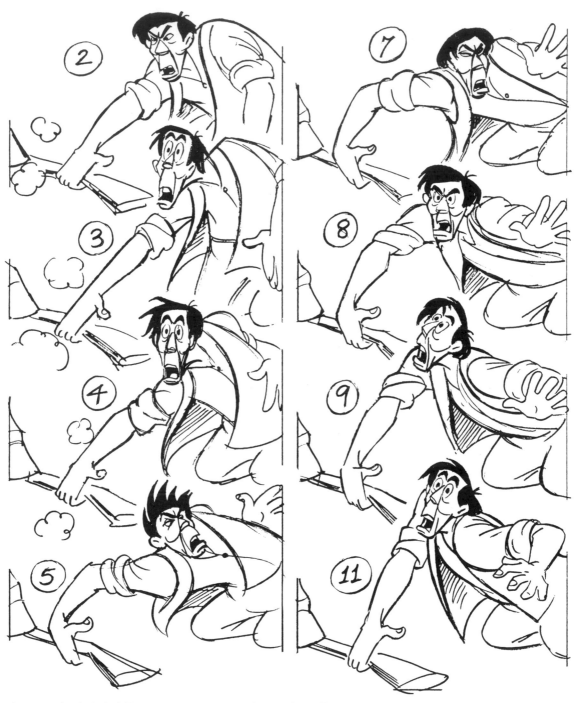

An example of a 'take'. Farmer Jones is about to pick up his shotgun when it is stepped on by Boxer, the horse, trapping Jones's fingers. He tries to pull his hand away on drawing 3, then, after a quick wriggle of pain on drawing 5, looks up in surprise at Boxer on drawing 11. (From *Animal Farm* by Halas and Batchelor.)

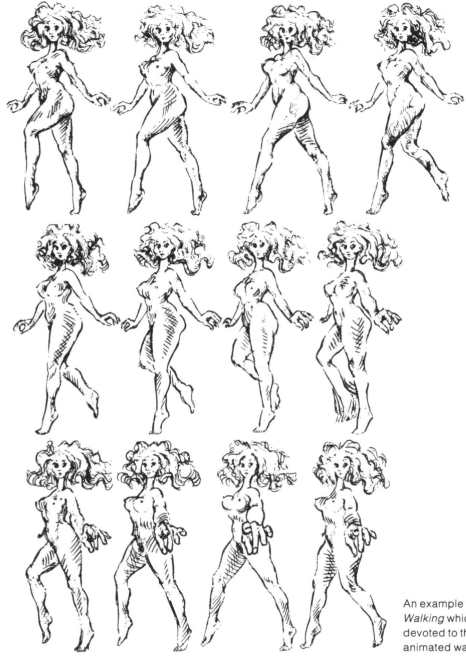

An example from Ryan Larkin's film *Walking* which was entirely devoted to the mechanics of animated walking cycles.

This example represents a 32 frame double frame cycle demonstrating how smoothly it is possible to carry out an extremely difficult human movement. It also makes good use of perspective animation through the exaggeration of the character's arm nearest to the camera.

139

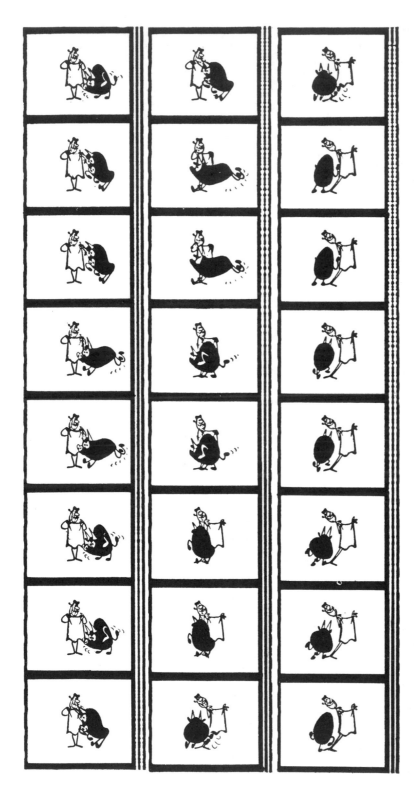

Animation samples enlarged from actual film frames show the timing of certain actions:

1 The Matador, in the film *The Insolent Matador*, fighting a furious bull. In spite of the high speed of this action, it is possible to animate in double frames. The economy of work could be considerable and the audience would not notice the difference in the smoothness of the action.

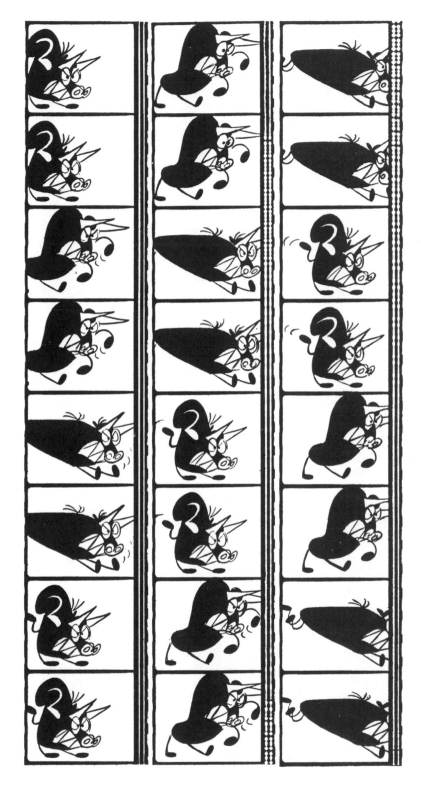

The bull charge in the film *The Insolent Matador*. Gesture and force of action convey the power and fury of this dangerous animal. Nevertheless, the action is conveyed in double frames and it loses none of its dynamism.

From Peter Foldes *Hunger* animated by the aid of a computer.

Computer facilities for the production of inbetween animation have become a pronounced labour saving device during the past few years. This is especially useful in achieving movement where transition of forms and shapes is dominant. It is a new approach which obviously has to be adjusted to, but inevitably it will eventually become an added tool in the hands of animators.